LETTERING

for ARCHITECTS and DESIGNERS

SECOND EDITION

LETTERING

for ARCHITECTS and DESIGNERS

SECOND EDITION

Martha Sutherland

JOHN WILEY & SONS, INC.

New York Chichester Weinheim Brisbane Singapore Toronto

Library of Congress Cataloging-in-Publication Data:

Sutherland, Martha, 1927–
 Lettering for architects and designers
 Includes index.
 1. Lettering. I. Title.
NK3600.S9 1989 745.6'1 88-27926
ISBN 0-471-28955-8

Printed in the United States of America

20 19 18 17 16

Examples from architects and architecture studios have been relettered from working drawings and detail sheets. Special thanks are due to the following institutions and individuals for permission to reproduce portions of their work.

Frank Lloyd Wright Memorial Foundation, p. 29
Edward Durrell Stone Archive, p. 30, by Special
 Collections of the University of Arkansas.
From Bruce Goff, p. 31, 32, by Palmer Boggs.
E. Fay Jones. p. 33, 34, 132, by the architect.
Hellmuth, Obata & Kassabaum, p. 35.
Harry Weese & Associates, p. 36.
Skidmore, Owings & Merrill, p. 37.
Caudill, Rowlett, Scott, p. 38, by the School of
 Architecture, University of Arkansas.
I.M. Pei & Partners, p. 39.
Ernest E. Jacks, p. 40, by the architect.
Crafton, Tull, Spann & Yoe, Inc., p. 133.
Benjamin Thompson & Associates, p. 134.

CONTENTS

CONTENTS

INTRODUCTION

Lettering skill is a valuable tool for architects and graphic designers alike. It should be developed from the very beginning of professional study along with drawing techniques, perspective, and principles of design.

This is an exemplar book, meant to acquaint the student with a range of lettering styles acceptable to the profession and with some of the graphic potential of letters on presentation sheets and title blocks.

Small-scale letters are the architect's stock-in-trade, and yet they are the least susceptible to mechanical aids such as Leroy or press-on letters. Therefore the book devotes a great deal of attention to the various forms of small letters. Examples are included that are taken from drawings by professional architects and from architecture offices. The student may use the book to select and experiment with different shapes and styles before electing to pursue one to competence.

Large-scale letters are more flexible than small ones in terms of embellishment, shape, and scale. Eleven special alphabets for presentation sheets have been included, as well as ideas for the enhancement of of individual letters. There are fancy numerals and some tips on using felt-tipped markers. Backgrounds, infill, and color blocks are touched on.

It is hard to overestimate the importance of suitable, well-executed lettering to a student's success. It is not only part of skillful presentation, but can provide a valuable entrée into a professional office.

All of the lettering in this book has been done by hand and is reproduced to exact size, except where noted.

SMALL-SCALE LETTERS
Uppercase Letters in Pencil

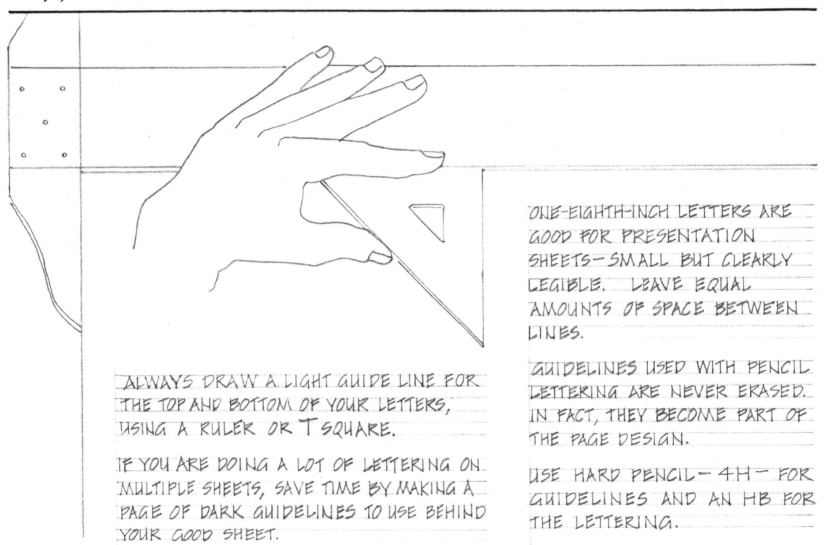

ALWAYS DRAW A LIGHT GUIDE LINE FOR THE TOP AND BOTTOM OF YOUR LETTERS, USING A RULER OR T SQUARE.

IF YOU ARE DOING A LOT OF LETTERING ON MULTIPLE SHEETS, SAVE TIME BY MAKING A PAGE OF DARK GUIDELINES TO USE BEHIND YOUR GOOD SHEET.

ONE-EIGHTH-INCH LETTERS ARE GOOD FOR PRESENTATION SHEETS—SMALL BUT CLEARLY LEGIBLE. LEAVE EQUAL AMOUNTS OF SPACE BETWEEN LINES.

GUIDELINES USED WITH PENCIL LETTERING ARE NEVER ERASED. IN FACT, THEY BECOME PART OF THE PAGE DESIGN.

USE HARD PENCIL—4H—FOR GUIDELINES AND AN HB FOR THE LETTERING.

A HARD PENCIL IS USED FOR THE GUIDELINES BECAUSE IT HAS A SMALL-DIAMETER LEAD AND THE LINES IT MAKES ARE VERY THIN. A PAGE OF RULED GUIDELINES WILL BECOME PROGRESSIVELY LESS ACCURATE IF THE THICKNESS OF THE LINE ITSELF BE-COMES PART OF THE MEASUREMENT.

THE GUIDELINES MAY BE MADE BY MEASURING 1/8-INCH INCREMENTS WITH THE RULE AND THEN USING THE T SQUARE TO DRAW THE LINES. IF MANY LINES ARE INVOLVED THIS IS LIKELY TO BE INACCURATE. THERE ARE OTHER INSTRUMENTS TO FACILITATE THE PROCESS.

THE AMES LETTERING GUIDE OR A LETTERING TRIANGLE CAN BE GREAT TIME SAVERS. THE DIAGONAL LINE OF SPACED HOLES ON THE LEFT SIDE OF THE AMES GUIDE WILL PRODUCE 1/8-INCH LINES.

SET THE AMES GUIDE FIRMLY ON THE T SQUARE OR PARALLEL BAR, READABLE SIDE UP. SHARPEN THE 4H PENCIL, INSERT IN HOLE, AND PULL THE GUIDE TO THE RIGHT THE DESIRED DISTANCE. MOVE THE PENCIL DOWN ONE HOLE AND PULL TO THE LEFT.

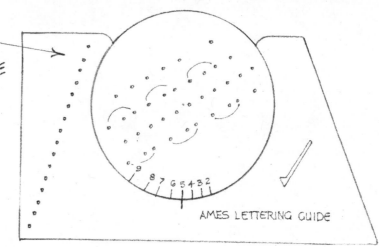

AMES LETTERING GUIDE

THE LETTERING TRIANGLE FUNCTIONS IN THE SAME MANNER AS THE AMES GUIDE. THE NUMBERS REPRESENT INCREMENTS OF 1/32 INCH AND THE STAGGERED SETS OF HOLES ARE FOR MAKING UPPER- AND LOWERCASE LETTERS.

IN A BRADDOCK-ROWE LETTERING TRIANGLE THE HOLES OVER THE 4 ARE AT 1/8-INCH INTERVALS.

SNUG THE PENCIL AGAINST THE T SQUARE, INSERT THE PENCIL IN THE HOLE, AND DRAW IT ALONG AS WITH THE AMES GUIDE.

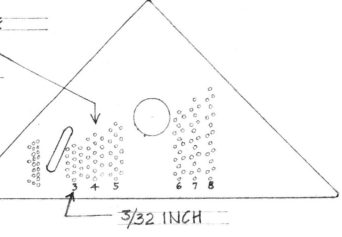

3/32 INCH

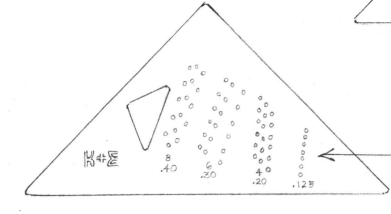

SOME TRIANGLES HAVE THE 1/8-INCH SPACING ON THE RIGHT SIDE, LABELED .125.

AS THE LETTER SHAPES ARE BEING PRACTICED IT IS IMPORTANT TO CONSIDER THE QUALITY OF THE LINE. PART OF THE BEAUTY OF HAND LETTERING COMES FROM THE NATURE OF THE MARK AND ITS VARIETY.

START YOUR LINE BY PRESSING THE PENCIL SLIGHTLY IN PLACE—NOT ENOUGH TO MAKE A DOT, BUT JUST ENOUGH TO ENSURE A FIRM BEGIN-NING. LIGHTEN THE PRESSURE A BIT TO MAKE THE STROKE, THEN PRESS SLIGHTLY AT THE END BEFORE LIFTING THE PENCIL, OR BRING YOUR STROKE BACK ON ITSELF A TINY DISTANCE.

ENLARGED, THE LINE WILL LOOK LIKE THIS ————————

OPTICAL ILLUSION MAKES THE ENDS OF LINES APPEAR LIGHTER THAN THE MIDDLE, HENCE ONE NEEDS TO COMPENSATE BY WEIGHTING THE BEGIN-NING AND THE END.

OPTICAL ILLUSION ALSO TENDS TO MAKE THE ROUND LETTERS APPEAR SMALLER THAN THEY REALLY ARE. STROKE THE O, C, G, Q, AND D THE FULL SPACE OR A LITTLE MORE.

THIS LOOKS GOOD ———→ HOW HOT THE SOUP IS
THIS DOES NOT ———→ HOW HOT THE SOUP IS

A COMMONPLACE IN ARCHITECTURAL LETTERING TODAY IS TO HAVE THE DOWNSTROKE, OR STEM, THIN AND THE HORIZONTAL HEAVY. WITH A PENCIL THIS IS ACCOMPLISHED BY ANGLING THE POINT. SHARPEN THE PENCIL AND THEN BEVEL THE POINT SLIGHTLY BY STROKING IT ON A SCRATCH SHEET.

IN MAKING THE DOWNSTROKE, TURN THE PENCIL SO THAT THE STEM IS SHARP AND THIN, THEN ROLL IT FRACTIONALLY SO THAT THE HORIZONTAL LINE IS HEAVIER.

AEIOUBCDFGHK

THESE LINE QUALITY TECHNIQUES WILL GIVE THE LETTERING A PLEASING SURFACE TEXTURE.

THE BASIC BLOCK LETTER IS THE FOUNDATION OF A VARIETY OF ALPHABETS.
ABSOLUTELY SERVICEABLE, TRUSTWORTHY, AND ACCEPTABLE IN ANY LAYOUT OR
ON ANY DRAWING, IT HAS THE GREAT ADVANTAGE OF BEING A PURE AND NEU-
TRAL STYLE, EASILY ADAPTABLE LATER ON TO YOUR OWN PERSONALITY OR THAT
OF ANY ARCHITECTURE OFFICE.

BLOCK LETTERS ARE ALSO CALLED CAPITAL LETTERS OR MAJUSCULE LETTERS.

USE A TRIANGLE FROM THE BOTTOM OF THE TSQUARE FOR ALL VERTICAL STROKES,
INCHING IT ALONG FROM LETTER TO LETTER.

ABCDEFGHIJKLMNOPQRSTU
VWXYZ

IT IS USEFUL TO THINK OF ALL THE LETTERS AS BEING THE SAME SIZE
AND APPROXIMATELY SQUARE, ALTHOUGH M AND W ARE A LITTLE
WIDER.

SOME NOMENCLATURE:

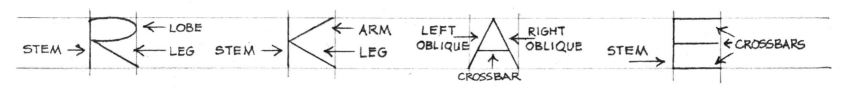

SOME GROUND RULES:

- TAKE THE LOBE OF THE R ALL THE WAY IN TO THE STEM → R .
- TAKE THE ARM OF THE K ALL THE WAY IN TO THE STEM → K .
- PLACE CROSSBARS AT THE CENTER OF THE STEM OR SLIGHTLY ABOVE → A E F H.
- SPLAY THE LEGS OF M AND W A LITTLE.
- TAKE THE CENTER OBLIQUES OF M AND W TO THE LINE M̃ W̃.
 THIS M̃ AND THIS W̰ ARE WEAK AND UNLOVELY.
- MAKE THE ROUND LETTERS FAT → O C G Q D
- TRY TO LEAVE A WEDGE BETWEEN THE LOBES OF B → THIS B, NOT THIS B.
- MAKE G ONE STROKE (G OR TWO STROKES C ᵓ G.

MAXIM:

NEVER CROSS YOUR I's OR YOUR J's IN A SIMPLE BLOCK ALPHABET.

IJ

TO DO SO IS TO PUT SERIFS ON AN OTHERWISE UNSERIFED ALPHABET.

HERE IS AN EXAMPLE OF THE BASIC BLOCK LETTER.

I DO NOT BELIEVE THAT EVER ANY BUILDING WAS TRULY
GREAT, UNLESS IT HAD MIGHTY MASSES, VIGOROUS AND
DEEP, OF SHADOW MINGLED WITH ITS SURFACE. AND
AMONG THE FIRST HABITS THAT A YOUNG ARCHITECT
SHOULD LEARN, IS THAT OF THINKING IN SHADOW, NOT
LOOKING AT A DESIGN IN ITS MISERABLE LINY SKEL-
ETON; BUT CONCEIVING IT AS IT WILL BE WHEN THE
DAWN LIGHTS IT, AND THE DUSK LEAVES IT....

JOHN RUSKIN
THE SEVEN LAMPS OF ARCHITECTURE

SPACING IS A SERIOUS BUSINESS IN CALLIGRAPHY AND GRAPHICS. IT WILL BE DEALT WITH MORE FULLY LATER.

- FOR THE ARCHITECT, WHEN USING SMALL-SCALE LETTERS IT IS EASIEST TO PACK THE LETTERS CLOSE TOGETHER AND NOT WORRY ABOUT SPACING. THIS CONDENSED LOOK IS CURRENTLY POPULAR IN ARCHITECTURE OFFICES.

- ALTHOUGH THE LETTERS THEMSELVES MAY BE CLOSE TOGETHER, CONTINUE TO KEEP EACH ONE THE APPROXIMATE SHAPE OF A SQUARE.

- LEAVE THE SPACE OF A FAT O BETWEEN WORDS.

- LEAVE THE SPACE OF TWO OR THREE FAT O's BETWEEN SENTENCES.

- KEEP INFORMATION IN TIGHT BLOCKS WITHOUT INDENTATION.

THE BASIC BLOCK LETTER IS CAPABLE OF MANY VARIATIONS THAT GIVE IT PEP AND VARIETY WHILE STILL RETAINING ITS CLEARNESS AND LEGIBILITY.

THE MOST COMMON VARIANT OF THE PLAIN BLOCK LETTER IS A CHANGE IN THE PLACEMENT OF THE CROSSBAR — EITHER MOVING IT UP OR DOWN — THEREBY MAKING THE LETTERS EITHER HIGH- OR LOW-WAISTED.

FEED FELIX A HALF HAM

FEED FELIX A HALF HAM

- IN EITHER CASE BE CONSISTENT — DON'T MIX "EMPIRE" WITH "FLAPPER."

- A HIGH-WAISTED ALPHABET SHOULD BRING IN THE LOBE OF R, P, AND B HIGH UP ON THE STEM. K AND S SHOULD BE TREATED SIMILARLY.

- A LOW-WAISTED ALPHABET ALSO NEEDS TO CONFORM → B K P R S

ANOTHER COMMON VARIANT IS CHANGING THE SHAPE OF THE ROUND LETTERS FROM A FAT CIRCLE TO AN OVAL.

- OVALS THAT STAND STRAIGHT UP AND DOWN ARE LACKING IN GRACE. SLANT THEM. O C G Q D

- KEEP ALL STEMS VERTICAL.

ORDER GOPHER COVERS FOR GROMLEY

- NOW GO ONE STEP FURTHER AND ANGLE THE LOBES OF B, P, AND R LIKE THIS ⟶ B P R

BELOW IS A SAMPLE OF LETTERING USING OVALS.

FRANK LLOYD WRIGHT IS ALLEGED TO HAVE SAID THAT DOCTORS BURY THEIR MISTAKES, BUT ARCHITECTS PLANT IVY. TODAY THE ADVICE MIGHT BE TO PLANT KUDZU FOR A QUICK FIX.

A VARIATION FREQUENTLY USED BY PROFESSIONALS CHANGES HORIZONTAL STROKES INTO SLANTING ONES. AEFHTLU

- DON'T SLANT Z OR IT WILL APPEAR TO BE DANCING ⟶ *ʒ*.

- MAKE SURE THE STEMS TOUCH THE TOP AND BOTTOM GUIDELINES.

- START THE TOP CROSSBAR ON THE STEM BELOW THE TOP GUIDELINE AND BRING IT UP TO TOUCH THE LINE E E. FOLLOW THE SAME PRO-CEDURE WITH B, P, D, AND R.

- THE SLANTING STROKE MAY START JUST TO THE LEFT OF THE STEM.

WORK AT KEEPING THE SLANT UNIFORM.

THE TEXT OF THIS BOOK IS WRITTEN OUT IN THIS STYLE, USING OVAL-SHAPED "ROUND" LETTERS AND SLANTING "HORIZONTALS." ALL SORTS OF COMBINATIONS ARE POSSIBLE. THERE IS NO REASON NOT TO BE CREATIVE, BUT BE CONSISTENT AND REMEMBER

LEGIBILITY IS THE ONE IMPERATIVE

SOMETIMES LETTERS CAN BECOME A KIND OF GRAPHIC SHORTHAND.

A = △ OR A AS IN BAN△N△ OR MACADAM

HE = HE AS IN HEAVY

W = \V AS IN \VET

AE = Æ AS IN ÆRATE

OR = OR AS IN ORDER

LETTERS LIKE THESE ARE CALLED ECCENTRIC.

- LESS DESIRABLE VARIATIONS INCLUDE FLATTENING THE CENTERS OF THE M AND W LIKE THIS ⟶ M W. THESE FORMS ARE HARD TO READ AND NOT VISUALLY PLEASING.

- DROPPING THE CROSSBAR OF THE N OR, CONVERSELY, RAISING IT LIKE THIS ⟶ N OR N ARE COMMON MUTATIONS. IT IS BEST TO AVOID THESE SINCE THEY CAN BE EASILY MISTAKEN FOR M OR H.

BELOW IS A SAMPLE OF LETTERING USING SOME ECCENTRIC LETTERS AND ROUND RATHER THAN OVAL CHARACTERS.

BETWEEN THOSE WHO BELIEVE THAT THE CITY WILL DISAPPEAR AND THOSE WHO TRY TO PRESERVE IT BY CHANGING ITS STRUCTURE, THERE IS NO DISA- GREEMENT ON THE POINT THAT THE INTRICATE DIS- ORDER OF THE PRESENT DAY CANNOT CONTINUE, THAT MAN CANNOT LIVE FOREVER ON ASPHALT.

SIGFRIED GIEDION
TIME, SPACE, AND ARCHITECTURE

BELOW IS A SAMPLE SUBSTITUTING OVAL FOR ROUND, AND SLANTED FOR HORIZONTAL.

IT IS A GRAND CONCEPTION INDEED, TO VISUALIZE THE QUAL- ITIES OF A LANDSCAPE BY MEANS OF A MAN-MADE STRUCTURE, AND THEN TO GATHER SEVERAL LANDSCAPES SYMBOLICALLY IN ONE PLACE.

CHRISTIAN NORBERG-SCHULTZ
GENIUS LOCI

ANOTHER VARIETY OF ECCENTRIC IS BASED ON A TYPEFACE CALLED KABEL.
ESSENTIALLY IT FOLLOWS A RULE OF ALL STRAIGHT-LINE LETTERS BEING VERY
NARROW AND ALL ROUND LETTERS BEING VERY WIDE.

A B C D E F G H I J K L M N O P Q
R S T U V W X Y Z

THE ROUND LETTERS MAY BREAK THROUGH THE LETTERING LINES. STYLIZE
THE S FOR A LITTLE MORE FLAIR. MASS THE LETTERS TOGETHER.

OF ALL THE STRUCTURES ERECTED BY HUMAN LABOR,
NOAH'S HOUSE UPON THE WATERS REMAINS IN A CLASS
ALL OF ITS OWN. THE ONLY PIECE OF ARCHITEC-
TURE EVER BUILT ACCORDING TO THE LORD'S SPECIFI-
CATIONS, THE ONLY ONE INSTRUMENTAL IN POSTPONING
MAN'S EXTINCTION, IT IS ALSO THE ONE WHICH LEAST
AFFECTED ARCHITECTURE IN GENERAL.

BERNARD RUDOFSKY
THE PRODIGIOUS BUILDERS

PROBABLY THIS ALPHABET LOOKS BETTER IN SMALL DOSES.

EVERYTHING THAT DECEIVES MAY BE SAID TO ENCHANT.

SLANTING THE BLOCK LETTERS CREATES ANOTHER KIND OF LOOK ON THE PAGE. THEY ARE MADE WITHOUT A TRIANGLE, ALTHOUGH TOP AND BOTTOM GUIDELINES ARE ALWAYS USED. THE SLANTED SIDE OF THE AMES LETTERING GUIDE OR THE SIMILAR INCLINED EDGE INSIDE THE LETTERING TRIANGLE MAY BE USED TO MAKE TWO OR THREE SLANTED GUIDELINES TO AID ACCURACY.

I AM SELF TAUGHT IN EVERYTHING, EVEN IN SPORTS. AND BEING SELF TAUGHT, I KNEW THE GREATEST ANGUISH UP TO THE AGE OF THIRTY-FIVE. I WOULD NOT ADVISE ANYONE TO FOLLOW THE SAME COURSE.

LE CORBUSIER
"TALKS WITH STUDENTS"

FOR VARIETY AND EMPHASIS THE FIRST LETTERS CAN BE MADE LARGER WHILE RETAINING THE SAME FORM.

ONCE THE IMPRESSION HAS BEEN RECORDED BY PENCIL, IT STAYS FOR GOOD, ENTERED, REGISTERED, INSCRIBED. THE CAMERA IS A TOOL FOR IDLERS, WHO USE A MACHINE TO DO THEIR SEEING FOR THEM. TO DRAW ONESELF, TO TRACE THE LINES, HANDLE THE VOLUMES, ORGANIZE THE SURFACE... ALL THIS MEANS FIRST TO LOOK, AND THEN TO OBSERVE, AND FINALLY PERHAPS TO DISCOVER... AND IT IS THEN THAT INSPIRATION MAY COME.

LE CORBUSIER
"MY WORK"

CLASSIC LETTER PROPORTIONS COME DOWN TO US FROM THE ROMANS, WHOSE ALPHABET IS ONE OF THE MOST BEAUTIFUL EVER DEVISED. THEY USED VARIABLE LETTER WIDTHS.

- IN THE CLASSIC ROMAN ALPHABET THE FOLLOWING LETTERS ARE NARROW:

 BEFPRS

- THESE LETTERS ARE MEDIUM-WIDTH ⟶ AHJKLNTUVXYZ.

- ALL THE ROUND LETTERS, PLUS M AND W, ARE WIDE ⟶ CDGOQ MW

 THE ROMANS HAD NO J, U, OR W.

IN ADAPTING CLASSICAL PROPORTIONS TO ARCHITECTURAL LETTERING, KEEP B,E,F,P,R, AND S NARROW AS A MATTER OF COURSE. MAKE T, L, AND U NARROW TOO, IF DESIRED. KEEP THE ROUND LETTERS FAT, M AND W WIDE, AND ALL THE REMAINING LETTERS THE SHAPE OF A SQUARE. BELOW IS AN EXAMPLE OF PROPORTIONED LETTERING.

WHEN I AM WORKING ON A PROBLEM, I NEVER THINK ABOUT BEAUTY, I THINK ONLY HOW TO SOLVE THE PROBLEM. BUT WHEN I HAVE FINISHED, IF THE SOLUTION IS NOT BEAUTIFUL, I KNOW IT IS WRONG.

BUCKMINSTER FULLER

WHEN LETTERS ARE SPREAD APART SPACING BECOMES VERY IMPORTANT.

SPACING IS AN OPTICAL PROBLEM, NOT A MECHANICAL ONE. THE PERCEIVED AREA BETWEEN LETTERS IS WHAT DETERMINES SPACING, NOT THE MEASURED DISTANCE BETWEEN EXTREMITIES.

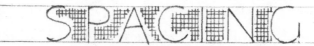

- STRAIGHT-LINE LETTERS NEED MORE AREA BETWEEN THEM.

 THIS ——→ THIN NOT THIS ——→ THIN

- ROUND LETTERS NEED LESS AREA BETWEEN THEM.

 THIS ——→ BOOK NOT THIS ——→ BOOK

- AVOID NESTLING THE OBLIQUE STROKES.

 THIS ——→ AWAKE NOT THIS ——→ AWAKE

THE SPACE ENTIRELY ENCLOSED WITHIN A LETTER AS WELL AS THE SPACE PARTIALLY ENCLOSED IS CALLED THE COUNTER. EVERY LETTER EXCEPT I HAS A COUNTER SPACE.

COUNTER SPACE (AS ITS NAME SUGGESTS) IS PART OF THE AREA CONSIDERED WHEN SPACING LETTERING. THAT IS WHY DOUBLE O'S NEED TO BE SNUGGED CLOSE TOGETHER; THEIR COMBINED COUNTERS GIVE A VERY LIGHT LOOK TO THE WORD. BOOK

COUNTER

BELOW ARE EXAMPLES OF WELL-SPACED, SMALL-SCALE BLOCK LETTERS.

ARTISTS WHO ARE FOND OF READING INVARIABLY
DERIVE THE GREATEST BENEFIT FROM THEIR
STUDIES, ESPECIALLY IF THEY ARE SCULPTORS OR
PAINTERS OR ARCHITECTS. BOOK LEARNING ENCOUR-
AGES CRAFTSMEN TO BE INVENTIVE IN THEIR WORK.

GEORGIO VASARI
LIVES OF THE ARTISTS

NINE PERSONS OUT OF TEN — PERHAPS NINETY-NINE IN A
HUNDRED — WHO COME WITHIN SIGHT OF THE TWO SPIRES
OF CHARTRES WILL THINK IT A JEST IF THEY ARE TOLD
THAT THE SMALLER OF THE TWO, THE SIMPLER, THE ONE
THAT IMPRESSES THEM LEAST, IS THE ONE WHICH THEY
ARE EXPECTED TO RECOGNIZE AS THE MOST PERFECT
PIECE OF ARCHITECTURE IN THE WORLD.

HENRY ADAMS
MONT-SAINT-MICHEL AND CHARTRES

HOW SMALL IS SMALL?

GIVEN A SHARP ENOUGH PENCIL, LETTERING CAN BE VERY TINY INDEED. BE SURE TO LEAVE ENOUGH SPACE BETWEEN WORDS SO THAT THE STRAINING EYE CAN DISTINGUISH THEM EASILY.

- DISPENSE WITH THE STRAIGHTEDGE FOR VERTICALS WHEN MAKING TINY LETTERS.

CIVILISED MAN...MUST FEEL THAT HE BELONGS SOMEWHERE IN SPACE AND TIME; THAT HE CONSCIOUSLY LOOKS FORWARD AND LOOKS BACK. AND FOR THIS PURPOSE IT IS A GREAT CONVENIENCE TO BE ABLE TO READ AND WRITE.

KENNETH CLARK
CIVILISATION

- FOR TINY LETTERING IT HELPS TO LEAVE MORE SPACE BETWEEN LINES.

LEON BATTISTA ALBERTI, THE TYPICAL UNIVERSAL MAN OF THE RENAISSANCE, HAD ALSO BEEN AN ARCHI-TECT, AND IF WE MAY STILL CONSIDER ARCHITECTURE TO BE A SOCIAL ART — AN ART BY WHICH MEN MAY BE ENABLED TO LEAD A FULLER LIFE — THEN PERHAPS THE ARCHITECT SHOULD TOUCH LIFE AT MANY POINTS AND NOT BE TOO NARROWLY SPECIALISED.

KENNETH CLARK
CIVILISATION

HOW LARGE CAN SMALL LETTERS BE AND STILL BE CALLED SMALL-SCALE?

LETTERS MORE THAN ¼ INCH HIGH ARE ALMOST LARGE-SCALE AND ARE MORE DIFFICULT TO EXECUTE THAN SMALL-SCALE LETTERS BECAUSE THE LONGER THE STROKES THE MORE SKILL IT TAKES TO MAKE THEM STRAIGHT AND UNIFORM. ALSO, THE VERY THINNESS OF THE PENCIL LINE TENDS TO MAKE THE LETTERS LOOK WEAK AND SPINDLY. LETTERS LARGER THAN THOSE BELOW (¼ INCH) WILL USUALLY BE MADE WITH A DIFFERENT TOOL.

- ECCENTRIC LETTERS AND CONDENSED SPACING

 ART MATTERS ONLY IF ALL CAN SHARE IT

- ROMAN LETTER SHAPES AND SPACING

 ART MATTERS ONLY IF ALL CAN SHARE IT

- SLANTED LETTERS CAN BE COMPACTED EASILY

 ART MATTERS ONLY IF ALL CAN SHARE IT

- THE ½-INCH LETTERS BELOW LOOK THIN AND LIGHT

 ART MATTERS ONLY IF

- TRY COMPACTING THE LETTERS TO ADD TO THE WEIGHT

 ART MATTERS ONLY IF ALL CAN

IN ARCHITECTURAL PRACTICE, NUMERALS ARE AS IMPORTANT AS LETTERS. THE TWO SHOULD HARMONIZE IN STYLE.

- NUMERALS TO GO WITH BASIC BLOCK LETTERS SHOULD BE NEAT, STRAIGHT, EQUAL IN SIZE, AND APPROXIMATELY SQUARE.

 1234567890 MONDAY, JANUARY 28, 1954

- LETTERS WITH ANGLED "HORIZONTALS" SHOULD BE ACCOMPANIED BY ANGLED NUMERALS.

 1234567890 TUESDAY, SEPTEMBER 30, 1674

- SLANTED LETTERS NEED SLANTED NUMERALS.

 1234567890 WEDNESDAY, OCTOBER 14, 2001

- NUMERALS ARE THE SAME HEIGHT AS BLOCK LETTERS OR SLIGHTLY TALLER.

 ABC 123 DEF 456 GHI 789

- FRACTIONS WILL BE SLIGHTLY LARGER THAN THE WHOLE NUMBERS.

 3/4"=1'-0" 1/4"=1'-0" 3/8"=1'-0" 5/16"=1'-0"

This section of the book begins with examples from three well-known architects of the recent past — Frank Lloyd Wright, Edward Durrell Stone, and Bruce Goff.

Following those of Wright, Stone, and Goff are examples from the offices of today's busiest and most exciting architects. The lettering is taken from drawings and plans and in some cases has been done by one or more draftsmen in the office, adhering to the style established by the master. The pages are assembled from parts of many sheets. All the lettering is reproduced to exact size.

After the architects' examples are several pages lettered by students at the University of Arkansas.

FRANK LLOYD WRIGHT'S LETTERING HAS A SPACIOUS QUALITY THAT IS NOW CONSIDERED A TRADEMARK. CAREFUL SPACING GIVES IT ITS ELEGANCE.

MUCH OF THE LETTERING FROM WRIGHT'S OFFICE SHOWS CLASSIC ROMAN PROPORTIONS, I.E. A NARROW B, E, F, R, AND S, AND A FAT C, O, G, AND D, AS OPPOSED TO TODAY'S TREND TOWARD UNIFORM WIDTH.

NOTICE THE INTERESTING ART DECO LETTERS IN THE LAST LINE.

FRANK LLOYD WRIGHT ARCHITECT
TERRACE CIVIC CENTER
WINDY POINT RACINE

SHEET 1 GENERAL PLAN
MAIN HOUSE AULDBRASS
FRANK LLOYD WRIGHT

MADISON WISCONSIN
ALTERATIONS FALLINGWATER

PLAYHOUSE NO3 OAK PARK

EDWARD DURRELL STONE'S OFFICE USED SOME HIGHLY ECCENTRIC LETTERS. NOTICE THE STYLIZED R, K, B, AND S. TWO DRAFTSMEN ARE REPRESENTED HERE.

THEATER
BASEMENT & FIRST FLOOR PLAN

BASEMENT PLAN
STAIR Nº 2

THEATER
STAIR DETAILS

SECTION A-A
STAIR 112 1

SECOND FLOOR PLAN

THIRD FLOOR PLAN

LOUNGE ENTRANCE

SMOKE POCKET

MIRROR FRAME

SLIDING DOOR
JAMB

NEOPRENE SPONGE
WITH POLYURETHANE
BASE SEALANT

WASHED CONCRETE SURFACE
TERRAZZO AGGREGATE
1/3 #2 DEMARCO CREAM
2/3 #2 TAN QUARZITE
TEXAS TERRAZZO AND
MARBLE SUPPLY CO.

2" x 3" x 2'-0" BLACK GRANITE STRIPS

3" x 3" x 2'-6" BLACK GRANITE STRIPS

EXPANSION JOINTS CONSISTING OF
NEOPRENE SPONGE WITH POLYURETHANE
BASE SEALANT AT 18'-0" X 13'-4"
RECTANGLES

TELEPHONE BOOTHS

NEW ORLEANS, LOUISIANA

THE LARGE LETTERS WERE MADE WITH A PEN AND A GREAT SENSE OF FLAIR.

ELECTRICAL

E-1 LOWER LEVEL LIGHTING PLAN

E-2 UPPER LEVEL LIGHTING PLAN

E-3 LOWER LEVEL POWER PLAN

E-4 UPPER LEVEL POWER PLAN

E-5 POWER RISER DIAGRAM

E-6 LIGHTING FIXTURE SCHEDULE

NOTE:
WOOD SECTIONS HAVE BEEN ADAPTED FROM ORIGINAL F.LL.W. MILLWORK DRAWINGS SHEET 7. VERIFY SIZES WITH EXIST & NOTE CHARGES AS SHOWN ON THESE DRWS.

1. ALL ANGLES ARE A FACTOR OF 45°
2. IF NEEDED, A LEVELING COURSE OF SAND SHALL BE PLACED OVER THE VAPOR BARRIER TO HELP PROTECT IT DURING THE POURING OF THE CONC. SLAB.
3. NEW & EXISTING EXPOSED COLORED CONC. SLABS TO RECIECE TWO COATS OF "THOMPSON" WATER SEALER.
4. BOTTOM OF PIER FOOTINGS TO MATCH BOTTOM OF ADJACENT FOOTINGS
5. ALL CONCRETE TO BE f'c 3000 P.S.I., AND SHALL COMPLY WITH ASTM C94 AND THE RECOMMENDATIONS OF THE P.C.A.
6. ALL REINFORCING BARS TO CONFORM TO ASTM A-615, GRADE 60
7. WELDED WIRE FABRIC IN SLAB ON GRADE TO CONFORM TO ASTM

BRUCE GOFF INVENTED A STYLE OF LETTERING TO MATCH THE SPIRIT OF EACH COMMISSION.
SOME WERE IDIOSYNCRATIC, TO SAY THE LEAST.

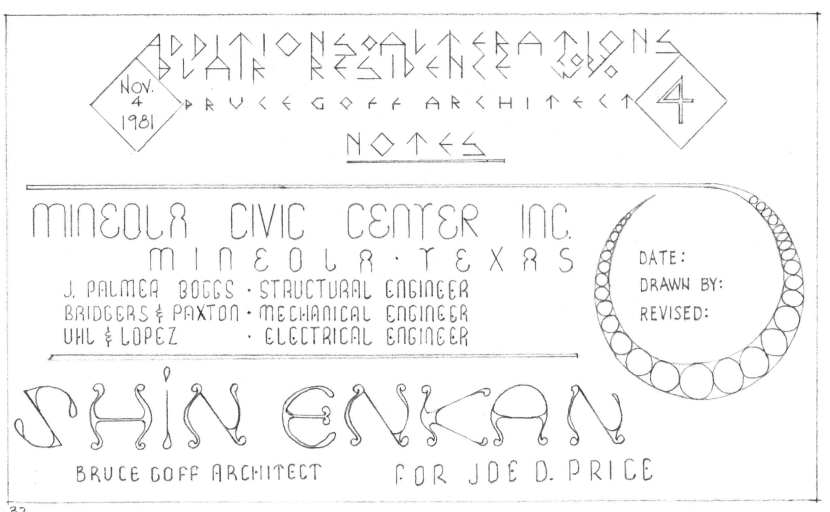

E. FAY JONES IS ANOTHER ARCHITECT WHO DESIGNS LETTERS IN THE SPIRIT OF THE COMMISSION HE IS WORKING ON.

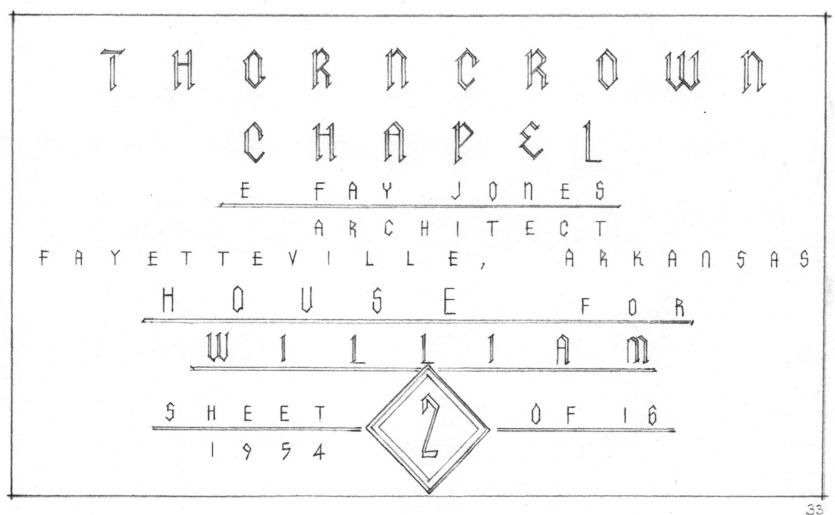

SLIDING DOOR HEAD

SCALE: 3" = 1'-0"

NOTE: HEAD & JAMBS
ON DOOR @ LAUNDRY
TO BE 5½" WIDE

DOOR W/ JALOUSIE INSERT

FIXED GL. HEAD @ BEAM

SCALE: 3" = 1'-0"

MORTISE &
TENON ALL
JOINTS - LET
IN TENONS
1½" @ EACH
CORNER ————

5/8" THK. INSUL. GLASS
(2 - 3/16" GLASS PANE
WITH 1/4" AIRSPACE)

FIXED GL. SILL @ PLANT

SCALE: 3" = 1'-0"

CASEMENT WINDOW HEAD/JAMB

ONE HALF FULL SCALE

1/4" x 3/8"
3/4" WOOD TRIM

ALUMINUM SLIDING
DOOR FRAME

UNIT LINE OR
MID-UNIT LINE

BRONZE ANODIZED
SCREEN (BY METAL
CRAFT PRODUCTS CO.)

1" INSUL. GLASS

BOSTON SIDING

OAK PANELING

1/2" INSUL. SHEATHING
UNIT LINE OR
MID-UNIT LINE

1" INSUL. GLASS —
OR 1/4" SINGLE GL.

2x6 IN METAL
CHANNEL - REMOVE
WHEN INSTALLING
GLASS

FILL CHANNEL &
SECURE GLASS
WITH POLYETHE-
LENE ROPE

26 GA. GALV. METAL
CHANNEL

UNIT LINE OR MID-
UNIT LINE

Example

HELLMUTH, OBATA & KASSABAUM

THE SECTIONS OF SMALL PRINT WERE LETTERED BY THREE DIFFERENT DRAFTSMEN.

NOTE:
FOR TREAD & RISER
DIMENSIONS SEE
PLANS & SECTIONS

CRIMP PIPE WHERE
HANDRAIL POSTS
MEET STRINGER

EXTERIOR TREE PLANTING

TREE WRAP

TREE GUARD-
SEE DTL

TREE GRATE-
SEE DTL

DAVIT SUPPORT:
PIPE SLEEVE
W/LOCK PIN-
SEE PLANS
FOR LOCATIONS
3/4" = 1'-0"

SKYLIGHT INTERIOR GUTTER

CONCRETE FILL
ON METAL DECK
COORDINATE W/
STRUCTURAL

HEADER CHANNEL
W/COVER PLATE

STEEL CLOSURE PLAT
WELDED TO ENDS OF
STRINGER

CONCRETE
FILLED METAL
PAN

PERFORATED
PIPE

GRANITE PAVING-
SEE DTL

MULCH BUBBLER
 8'x8'x8'
TREE BALL MIN.

BACKFILL

EXISTING SOIL

GRANITE PAVERS

INSULATION

WATERPROOF
MEMBRANE

NOTE: CONDITION
@ GRANITE PAVERS

FOR LOCATIONS
SEE PLANS

4A. 20-3

SECTION @ ROOF TERRACE & DAVIT

35

THE COLUMNS OF SMALL PRINT WERE LETTERED BY THREE DIFFERENT DRAFTSMEN.

DETAIL @ ROOF HATCH.	NO PARKING INSIDE GATES	FLUORESENT LIGHT FIXTURE WITH LOUVER
RIGID INSULATION BY HATCH MFGR. $1\frac{1}{2}" = 1'-0"$ 4/25/80	BLDG. 14 TRAILERS 10/14/1	METAL OVERHEAD STRUT
CONT. NEOPRENE SEAL BY HATCH MFGR. @¼"/FT.	BLDG. 14 CONTRACT LIMITS	STACK SHELVING (TYPICAL)
TREATED WOOD CANT		

PEDESTRIAN ACCESS

SECTION @ ROLLING DOOR 104

TYPICAL SECTION: STACK SHELVING LIBRARY NEW BOOK STACK

MECHANICALLY FASTENED TO SLAB (NOTCH @ HATCH BOLTS)	BLDG. 42 SITE PLAN SCALE: 1" = 40'-0"	90" HIGH SHELVING 7'-10½"
CONT. NEOPRENE PAD	ALL AREAS ARE APPROX IN SIZE AND LOCATION. COORDINATE WITH OWNER AND OTHER CONTRACTOR(S).	METAL OVERHEAD STRUT (SIZE AND SPACING PER MANUFACTURERS RECOMMENDATIONS, WITH MAX. SPACING 8'-0" O.C. TO SUPPORT LIGHT FIXTURES.)
BUILT UP ROOF SYSTEM		
2½"± RIGID INSULATION		
SLOPE TOPPING TO DRAIN @¼"/FT.	BLDG 42 CONTRACT LIMITS	
CONC. RF. SLAB		

TYP C.T. WALL PATTERN
SCALE 1:10

JAMB DET AT FIRE SHUTTER
W/ STONE CLADDING SCALE 1:5

POLISHED EXTRUDED ALUM. CLG FRAME PANEL
SECURED TO CLG CHANNEL SUBSTRUCTRE
W/ CLIPS AS REQ'D

BOT OF CLG CARRYING CHANNEL

CONT· GLAZING (TYR)

LIGHT FIXTURE W/ LENSE OR TYP.
GLASS PANEL.

16 DRYWALL ON METAL STUDS TYP
DET 23 AND 23A
STRUCTURAL·COL- SEE STRUCT
DRWGS

SATIN FIN SET PANEL LAMINA-
TED TO 20 PARTICLE BOARD

STRUCT COL — SEE STRUCTURAL
DRWGS

FIRE SHUTTER SIDE TRACK
AT DET 23 ONLY

DENOTES LINE OF BEAM ABOVE

BACK PAINTED LAMINATED GLASS
CLG PANEL (TYP)

POLISHED EXTRUDED ALUM FRAME

AIR SLOT OR BLACK SHOP PTD
BLANK-OFF PANEL — SEE MECH· DRWGS

FLUSH SPRINKLER COVER SHOP
PTD TO MATCH BLANK-OFF PANEL-
FOR LOCATION SEE REFLECTED CLG PLANS

BACK PAINTED GLASS TYP PANEL
OR LIGHT FIXTURE W/ LENSE —
SEE REFLECTED CLG PLANS
FOR LOCATION

HANGING CLIP LOCATION (TYP)
CLIP FASTENER

FACE OF GRANITE
16 DRYWALL COL
ENCLOSURE

COL W/ FIRE·SHUTTER AT 3RD LEVEL

TYP. COL AT TOWERS

ROOF FRAMING PLAN - AUDITORIUM LOW ROOF
ALTERNATE NO 1

EXISTING HANDHOLE FOR CLOCK,
T.V. AND TELEPHONES (PHASE 1)
CONFLICTS WITH PHASE III
COLUMN FOOTINGS.
5-4"C.

INSTALL NEW HANDHOLE FOR POWER
CABLES-INTERCEPT EXISTING CON-
DUITS AND REROUTE VIA HANDHOLE
TO PANEL BOARDS. SPLICE ALL CA-
BLES IN HANDHOLE ONLY AND EX-
TEND TO PANEL BOARDS. RUN NECES-
SARY TEMPORARY CABLES EITHER
IN GROUND OR ON ROOF TO KEEP
ESSENTIAL A/G, OTHER EQUIPMENT
OPERATING DURING THIS CHANGE.

NOTES:
RE: FIELD SUPERINTENDENT ON SITE
FOR VERIFICATION OF UNDERGROUND
CONDUIT & FEEDER LOCATIONS.

PHASE I
EXISTING CONSTRUCTION
MASONRY FIN WALL
METAL CLADDING

TWO CIRCUIT LIGHT TRACK WITH TYPE "C" FIXTURES MOUNTED
ON TRACK, SPACE FIXTURES EVENLY, 1' O.C. RE: 1GB
SINGLE CIRCUIT LIGHT TRACK WITH TYPE "C" FIXTURES MOUNTED
ON TRACK. SPACE FIXTURES EVENLY 1' 6" O.C. RE: 1GB
LOCATE CONTROL FOR DIMMERS OPERATING COVE LIGHTS & LOBBY
LIGHTS IN STORAGE ROOM AS SHOWN.

Example

I. M. PEI & PARTNERS

THREE DRAFTSMEN HERE: ONE LIBERAL, ONE CONSERVATIVE, AND ONE INDEPENDENT.

¾" HEAT. TREATED, TINTED REFLECTIVE GLASS

RIGID INSULATION

SPRAY. ON FIREPROOFING

CONCRETE SLAB

3" COMPOSITE FLOOR DECK

SUSPENDED CEILING

REMOVABLE ALUM. FASCIA

1" HORIZONTAL BLINDS

SECTION THRU LIGHTING NICHE

CLIP AS BY SL'D'G. DR. MANUF. THRU BOLTED. SHIM CLIP AS ½" FROM WALL, BEYOND LINTEL½

PL. 6"X ½"X 12'-2"

LINTEL @ LINE 5, C to C 3/3

REF: D-3 ON A-29 — S1-SK2 — HUB "G-G". DWG. #30 & CLARK DR. CO. DWG

1½" SCHEDULE 40 PIPE RUNNING LENGTH OF BEAM, WELDED TO BEAMS.

5/8" GWB STEEL STUD HANGER

ELEV. - EAST WALL OF TRUSTEES RM. 3X36

SCALE ¼"=1'-0"

RETURN AIR GRILLE

PLASTIC LAM. COUNTERTOP

TRUSTEES RM. 3X36 ELEVATION & SECTIONS

PAINTED WOOD SOFFIT & FASCIA

REC. DOWN LIGHTS

FABRIC COVERED G.W.B

PLAZA DRAIN
GRANITE PAVER
SETTING BED

CONCRETE SLAB
INSULATION
W. P. MEMBRANE

MET. STRAP ANCHORS W/ MET. SHIMS AS REQ'D TAP & SCREW TO TUBE FOR ANCHORAGE.

UPPER- AND LOWERCASE WORDS ARE RARELY MIXED. HERE IS AN INTERESTING EX-AMPLE IN WHICH LOWERCASE LETTERS ARE A KIND OF SHORTHAND FOR SHORT, SIMPLE WORDS.

NOTE

1. ESTABLISH ALL EXTERIOR FOOTINGS A MIN. of 24" BELOW FINISH GRADE and AT LEAST 12" BELOW EXISTING GRADE, WHICHEVER DEEPER.

2. CONCRETE for FOOTINGS: 3000 psi @ 28 DAYS

3. FILL ALL CONCRETE BLOCK CELLS WITH CONCRETE.

4. PROVIDE COMPLETE FOUNDATION TERMITE TREATMENT. (TERMINIX, ORKIN, OR EQUAL)

5. STEP FOOTINGS in 8" INCREMENTS AS SHOWN and AS OTHERWISE REQUIRED

6. FOOTINGS HAVE BEEN DESIGNED ASSUMING A SOIL BEARING VALUE of 4000 LB/SF. CONSULT ARCHITECT SHOULD CONDITIONS INDICATE THIS VALUE CANNOT BE OBTAINED.

THE 2'-8" SQ. UNIT, SHOWN HERE, HAS DETERMINED THE HORIZONTAL (PLAN) LAYOUT, FRAMING and DETAILING of THE HOUSE UNLESS DIMENSIONED OTHERWISE, WALLS HAVE ONE FACE or CENTER

NOTE

UNDERSLAB DUCTWORK: "SONOAIR" with GALVANIZED METAL BENDS, RE

ENCASE ALL UNDERSLAB DUCTWORK with 2½" MINIMUM CONCRETE, WRAP DUC VAPOR BARRIER, CONTINUE DRAINAGE FILL UNDER DUCTWORK.

SUPPLY and RETURN AIR RECTANGULAR DUCTWORK: RIGID FIBREGLAS with AIR BENDS, TRANSITIONS, etc.; STANDARD DUTY or HEAVY DUTY AS RECOMMENDED by

STUDENT LETTERING IS BOTH INTERESTING AND INFORMATIVE. THESE EXAMPLES WERE DONE BY STUDENTS AT THE UNIVERSITY OF ARKANSAS AND SHOW A RANGE OF APTITUDES AND PERSONAL INTERPRETATIONS.

STUDENTS WERE ASKED TO WRITE OUT THE ALPHABET AND THEN LETTER AN ABCEDARIUM. AN ABCEDARIUM IS A SENTENCE CONTAINING ALL THE LETTERS OF THE ALPHABET.

ABCDEFGHIJKLMNOPQRSTUVWXYZ

JOY LIKES WATCHING EXTRA ZEBRAS PLAY EVERY MONDAY UNDER QUICK FOG.
ELLEN POWELL, JUNIOR, ARCHITECTURE

ABCDEFGHIJKLMNOPQRSTUVWXYZ

THE QUICK BROWN FOX JUMPS OVER THE LAZY DOG

JACQUELINE LANGFORD, SENIOR, ARCHITECTURE

ABCDEFGHIJKLMNOPQRSTUVWXYZ

THE QUARANTINE INCLUDED ALL THE
VARSITY BASKETBALL PLAYERS AND
SOMEHOW EXCLUDED COACH F.Z. JAGGER.

BETTY SESSIONS, GRADUATE STUDENT, LANDSCAPE DESIGN,
DEPARTMENT OF HORTICULTURE AND FORESTRY

QUICK ! FIGHT WAXY JUMPING
SILVER AND BRONZE GEMS AND
EMPHASIZE QUICK OBSERVATION
OF WAXY GOLD JET. EDGE. . . .

ROBERT SCOTT GIBSON
SOPHOMORE
LANDSCAPE ARCHITECTURE

A B C D E F G H I J K L M N O P Q R S
T U V W X
Y Z
FOREIGNERS ARE UNEQUIVOCALLY
WALTZING TOWARD A MAJOR
INCREASE IN XENOPHOBES.

JANE C. CRAWFORD
GRADUATE STUDENT
HORTICULTURE

A B C D E F G H I J K L M N O P Q R S T U V W X Y Z
THE ANXIOUS RAZORBACKS WON THE
TOURNAMENT QUITE EASILY AFTER A
VERY GOOD PIZZA DINNER IN JAPAN.

CHERYL J. VESTAL , SENIOR , LANDSCAPE DESIGN

Lowercase Letters in Pencil

Lowercase letters, also called minuscules, are frequently used in notes, computations, and site plans. They are attractive and easy to read.

Most lowercase letter proportions are based on a four-unit module: two units for the body of the letter, one unit for the ascender, and one unit for the descender.

e ←body of the letter→ d ←ascender / ←body of the letter→ q ←descender

These are 3/8-inch letters, with the body of the letter 1/4 inch tall. The descender module is not usually counted when measuring letters. Instead, a space the height of the body of the letter is usually left between the lines of lettering.

Make capitals straight block style and the same height as the ascenders.

To make guide lines for lowercase letters:

Use the Ames Lettering Guide set at 6 (6/32 inch) and the first row of holes from the right. This will make letters 3/16 inch high. The body of the letter will be two-thirds of the total.

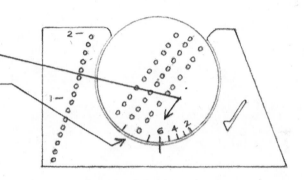

OR use a lettering triangle. Use the series of staggered holes labeled 6 (6/32 inch) to achieve the same results.

OR use a ruler. Measure 1/16 inch, 1/8 inch, 1/8 inch, and then repeat for as many lines as needed.

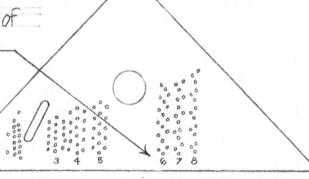

As with uppercase block letters, think of the body of the letter as occupying a square, except for the M and W, which will be wider.

Use a triangle below the T square for all verticals, inching it forward as you go.

abcdefghijklmnopqrstuvwxyz

Make a, b, c, d, e, g, o, p, q circular.
Arc the arm of the R far forward r.
Arc the top of the F far forward f.
Make the crossbar of the E straight and close to horizontal.

This → e, not this → e, or this → e.

The Q is distinguished from the G by a forward-turning tail q.
The ascender of the T does not reach all the way to the top line.
The T has a forward-turning stem t.

Lowercase block letters are good for quotes.

Like all art, (Modern Architecture) has revealed some of
the basic truths of the human condition and, again
like all art, has played a part in changing and reform-
ing that condition itself. From its first beginnings it
has shown us to ourselves as modern men and told us
what we are and want to be.

VINCENT SCULLY, JR.
MODERN ARCHITECTURE

Lowercase letters serve well as text under an eye-catching statement.

GREEK ARCHITECTURE WAS A FROZEN IDEAL
the decided curvature of the Parthenon and
other temples was not noticed, unbelievably
enough, until well into the nineteenth century

VINCENT SCULLY, JR.
MODERN ARCHITECTURE

Lowercase letters may be sloped

- FOR A DIFFERENT LOOK
- IF IT IS EASIER TO DO
- TO MAKE A BLOCK OF LETTERING STAND OUT FROM OTHER TEXT.

But though we may overlook it, space affects us and can control our spirit, and a large part of the pleasure which seems unaccountable, or for which we do not trouble to account—springs in reality from space.... To enclose a space is the object of building; when we build we do, but detach a convenient quantity of space, seclude it and protect it....

GEOFFREY SCOTT
THE ARCHITECTURE OF HUMANISM

If all spaces are ruled evenly, the letters are not well balanced.

Le Corbusier, after a lifetime of consistent effort, finally discovered a means for emboding the human act in architectural form.

VINCENT SCULLY, JR.
MODERN ARCHITECTURE

The lowercase letter has many possible variations.

- The letter A is the most varied → a, a, a, a, a, a.

- If you use these A's → a, a, a, a, the shapes of the other lobed letters should conform.

 a b c d e g o p q

 ali baba and the forty thieves

- Descenders may be straight or hooked → y, y, q, g, but be consistent. The exception is the P, which has no hook; This p, not this p.

- Y may be like this → y, or like this → y, or like this → y.

- K may be like this → k, or like this → k, or like this → k. It may have three strokes k or two strokes k.

- W may be like this → w.

Of all the styles of lowercase letters for pencil, this is one of the most attractive. It is clean, crisp, and pure, and has a contemporary look.

abcdefghijklmnopqrstuv·wxyz

In this paragraph the body of the letter is 1/8 inch high; the ascenders rise 1/16 inch above the top writing line and the descenders go 1/16 inch below the bottom writing line. Notice the similarity of the basic shape to the Variations of Block Letters on page 14. The lobes are oval shaped and slanted. Try to keep all lobes slanting at the same angle.

Some ground rules:

- Use a triangle against a straightedge for all verticals.
- Round over the top of the M and the N. This m̂ and this n̂, not this m̂.
- Make the arm of the R almost straight. This r̂, not this r̂.
- Q differs from G only in the small forward stroke on the descender.

 Q like this g G like this g

More ground rules:

• The dot over the i and j may be a short, oblique stroke rather than a dot, if desired. Start the stroke at the lowest point and flick the pencil up and to the right.

initially it inhibited action

• Make ascender of T shorter than ascenders of b, d, f, h, l, and k.

attach the title to the top

• The T has a foot that hooks up ⸜ t₅.

• Use capitals that match the lowercase letters.

ABCDEFGHIJKLMNOPQRSTUVWXYZ
a b c d e f g h i j k l m n o p q r s t u v w x y z

This style of lowercase letter can be used to advantage where small text is needed. In fact, it is progressively more attractive as it is reduced in size.

KEEP THE PENCIL VERY SHARP

Everywhere, moreover, the novel Gothic style, begun by Suger at St. Denis and continued by Maurice at Notre Dame de Paris, triumphantly displaced the Romanesque. At Senlis, Laon, Lisieux, Chartres, Meaux, Angers, Noyon, Poitiers, Soissons, and many smaller places a perpetual cloud of stone and mortar dust overhung the towns as the builders learned from, imitated, and strove to outdo one another.

At Paris the work proceeded steadily, at a reasonable pace. Maurice de Sully was a solid, deliberate man, not one to outrun his resources by a feverish initial campaign that would then lapse for years while new funds were frantically collected. Once the corner stone was laid – perhaps by Pope Alexander in person – and the elaborate dedication ceremonies completed, Maurice matched outgo to income and employed just enough workmen to keep the cathedral growing briskly but not wastefully.

RICHARD AND CLARA WINSTON
NOTRE DAME DE PARIS

The <u>really</u> small lettering needs to have more space between lines. The sample below was written out by Francis D. K. Ching in his book <u>Architecture: Form, Space, and Order.</u>

If located at a corner of a space, the vertical opening will erode the definition of the space and allow it to extend beyond the corner to the adjacent space. It will also allow incoming light to wash the surface of the wall plane perpendicular to it, and articulate the primacy of that plane in the space. If allowed to "turn the corner," the vertical opening will further erode the definition of the space, allow it to interlock with adjacent spaces, and emphasize the individuality of the enclosing planes.

A horizontal opening that extends across a wall plane will separate it into a number of horizontal layers. If the opening is not very deep, it will not erode the integrity of the wall plane. If its depth, however, increases to the point where it is greater than the bands above and below it, then the opening will become a positive element bounded at its top and bottom by heavy frames.

Mr. Ching is capable of going even smaller. This is also from <u>Architecture: Form, Space, and Order.</u>

Three spaces-the living, fireplace, and dining areas- are defined by changes in floor level, ceiling height, and quality of light and view, rather than by wall planes.

The spaces in these two buildings are individualistic in size and form.

The walls that enclose them adapt their forms to accommodate the differences between adjacent spaces.

Block Letters in Ink

Presentation sheets are frequently lettered in ink since its greater blackness carries better. Lettering can be done with the traditional ink pen — either fountain or dip — or now with markers that have plastic or fiber nibs. The fine point markers have many advantages as a substitute for "real ink." They eliminate the ink bottle with its obvious hazards; they are convenient; they make a uniform line; and the line doesn't smear the way pencil can. Although markers are improved each year, they are not without shortcomings. The mark sometimes bleeds through, unless special paper is used, and can spread when used on tracing vellum (the most likely support for presentation sheets). The mark is not black enough to use on acetate for overhead projectors. Finally, age can cause the strokes to deteriorate badly. Markers do not produce archival-quality lettering.

ARCHITECTURAL EXPRESSION, LIKE LANGUAGE, IS CONTINUALLY EVOLVING INTO NEW FORMS BASED ON, OR IN CONTRAST TO, THE PAST.

JAMES C. SNYDER
ANTHONY J. CATANESE
INTRODUCTION TO ARCHITECTURE

The example above was made with a marker. Notice that the subtle tonal qualities of the pencil are missing, but this is offset by the greater strength of the line.

The Speedball Series B (ball) nibs produce letters that resemble marker letters but have the advantages of real ink. The B nibs make a uniform-width line with rounded ends. This style of letter is usually called Gothic. The B Series ranges from B0, the fattest, to B6, the skinniest. Small letters, from 1/16 inch to 1/4 inch high, are made with the B5, B5 1/2, and B6.

Use non-waterproof ink in your pen. Waterproof, or India, ink tends to clog. Higgins nonwaterproof drawing ink in the squeeze-top bottle is good. Use the squeeze top to fill your pen. Drop the ink between the gold-colored reservoir on top and the silver body.

Practice until you are at ease with the proper writing angle. The nib needs to meet the paper firmly all across the flat end. Wash the point out in water after use. A corner of paper slipped between the reservoir and the body of the pen will clean it.

This is a sample of letters made with a B5 pen. They are 1/4 inch tall. It is hard to make them any smaller with a B5 nib.

NO SPACE, ARCHITECTURALLY, IS A SPACE UNLESS IT HAS NATURAL LIGHT...

LOUIS KAHN
LIGHT IS THE THEME

- Linger at the end of each stroke to ensure a smooth, round end to the line.
- Use block letters, wide and splayed, to prevent inking up counter spaces.
- No straightedge with ink pen — it will smear the wet ink.

For slightly smaller letters use the B5 1/2 pen. These are 3/16 inch tall.

IT WAS WRIGHT WHO SUMMED UP ALMOST EVERY-THING HIS GREAT CENTURY HAD MOST EARNESTLY DESIRED AND MADE A NEW ARCHITECTURE OUT OF IT.

VINCENT SCULLY, JR.
THE RISE OF AN AMERICAN ARCHITECTURE

The B6 pen is the most useful of this series, executing ⅛-inch letters capably, cleanly, and neatly.

PEDESTRIANS WILL FOLLOW THE LINE OF LEAST RESISTANCE, SHORTENING DISTANCES BY CUTOFFS, SWEEPING WIDE ON CURVES, EDDYING ABOUT OBSTACLES, AND FORMING POOLS ABOVE AND BELOW RESTRICTIVE CHANNELS SUCH AS STAIRS OR CORRIDORS.

JAMES C. SNYDER
ANTHONY J. CATANESE
INTRODUCTION TO ARCHITECTURE

The B6 will also handle lowercase letters nicely.

Architecture, besides fulfilling a function, sends a message to the onlooker through its varied and significant forms. No passerby confuses a church with a jail. It is perhaps not so obvious that structure too has a message of its own: it can be a message of strength or elegance, of waste or economy, of ugliness or beauty.

MARIO SALVADORI
WHY BUILDINGS STAND UP

The B6 pen is the most useful of this series, executing 1/8-inch letters capably, cleanly, and neatly.

PEDESTRIANS WILL FOLLOW THE LINE OF LEAST RESISTANCE, SHORTENING DISTANCES BY CUTOFFS, SWEEPING WIDE ON CURVES, EDDYING ABOUT OBSTACLES, AND FORMING POOLS ABOVE AND BELOW RESTRICTIVE CHANNELS SUCH AS STAIRS OR CORRIDORS.

JAMES C. SNYDER
ANTHONY J. CATANESE
INTRODUCTION TO ARCHITECTURE

The B6 will also handle lowercase letters nicely.

Architecture, besides fulfilling a function, sends a message to the onlooker through its varied and significant forms. No passerby confuses a church with a jail. It is perhaps not so obvious that structure too has a message of its own: it can be a message of strength or elegance, of waste or economy, of ugliness or beauty.

MARIO SALVADORI
WHY BUILDINGS STAND UP

Roman Alphabet in Ink

All of our present-day alphabets derive from classic Roman letters, which reflect the character of the Roman people. They loved to build and they built in accordance with deeply held principles of strength, logic, and balance. Their letters also were structural, in fact architectonic. It is because of the Romans that we respond to letters that are upright, forward looking, centered, and strong; it is not necessary for reading that the symbols be balanced or well spaced or elegant. Our graphics are as influenced by the Roman character today as they were 2,000 years ago. Because they designed letters to conform to the principles of engineering, the letters are solidly based and upright. Because they designed letters in the spirit of architecture, the letters have variety and flexibility.

To see just how influenced we are by the relationship of letter design to engineering, examine these two symbols.

This one has a solid foundation and a balanced structure. B

This one is top-heavy and weakly jointed. B

Subconsciously we can't escape the connotation of structural disaster in the second figure. We know it will surely collapse.

We have the same reaction to these letters. KRXS

The Romans' perfectly balanced letters look like this.

KRXS

Notice particularly the R with its soldierly stride, its leg planted firmly forward

R

The S is resilient but not bulbous.

S

The round letters are all-encompassing and, like the dome of Hadrian's Pantheon, meant to suggest both the earth and the heavens.

OCGQ

Letters such as these with bracketed (curved) serifs are difficult to execute and, for an architect, not worth the time necessary to master them. However, three kinds of Roman letters are very valuable: one, a sans serif (without serifs) alphabet; another called Roman Square Caps, which simply means that the serifs are straight strokes instead of bracketed ones; and finally an upper- and lowercase alphabet called Humanist Bookhand.

· But first, the tools necessary to make the thick and thin strokes.

The classic Roman letters have a pattern of thick and thin strokes that call for stems (verticals) to be thick and horizontals to be thin. The earlier pencil alphabets in this book have the opposite characteristics—thin stems and heavier horizontals. Such styles must be considered mutations of good Roman style.

The Speedball pen series C (chisel) nibs are excellent tools for making thick and thin letters. They are inexpensive and don't clog easily. The series ranges from C0, the widest, to C6, the narrowest.

• Small letters, from 1/16 inch to 1/4 inch, are made with the C4, C5, and C6.

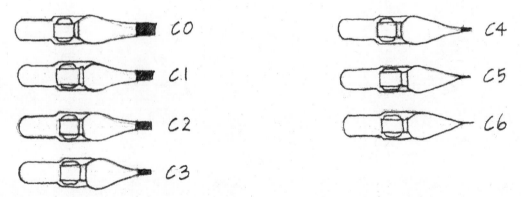

There are other suitable points. Brause and Co. has a series, and William Mitchell Roundhand and Italic pens work well, although the reservoir is separate and must be attached to each point.

Chisel-ended pens require special writing techniques.

- First, to make a good-looking thick and thin letter the pen needs to be CANTED. Cant is the degree to which the wide edge of the pen is away from the horizontal.

When the pen edge is parallel to the guidelines it is called a flat pen angle. To cant the pen, turn it counterclockwise until the edge is no longer parallel to the guidelines.

← flat pen angle ← canted pen angle

A flat pen angle makes a downstroke as wide as the point and a horizontal as thin as the steel. Obviously, if the pen is canted to its extreme (90°) position the downstroke will be as thin as the steel and the horizontal as wide as the pen.

- Second, the pen must be held upright in the hand so that the entire edge comes into contact with the page. Notice that the point has a slight bevel. It favors the right-handed person. There are left bevels made for "lefties."

For the most classic and beautiful letter the pen cant should be approximately 20°. This will produce a vertical stroke about twice as wide as the horizontal.

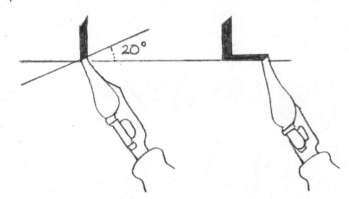

It is important to keep the pen at this cant for all the strokes except two, which will be noted. Kept at the proper cant, the pen will make the required thicks and thins all by itself.

Wide-edged pens should always be pulled, not pushed. Vertical (stem) strokes are pulled from top to bottom. Horizontals are pulled from left to right — not pushed from right to left.

straight-line letters I L H J E F T U

lobed letters B C D G O Q R S

oblique letters A K M N V W X Y Z

As was pointed out in the section on classic letter proportion, Roman letters vary in width. Here they are with thick and thin strokes.

narrow letters **IBEFPRSL**

medium letters **AHJKNTUVXYZ**

wide letters **CDGOQ MW**

- N and Z use a different cant. For the N, turn the pen more steeply so that the two stems are narrow and the oblique is wide. **N**

- Z needs a different cant only for the oblique stroke, which needs to be wider than the horizontals. Turn the pen clockwise to thicken the stroke. **Z**

- The accepted proportion of letter height to width is 7 or 8 to 1.

This style of Roman is called sans serif, meaning without serifs.

The Roman M and W are not upside-down images of each other. For the M, make the first stroke almost vertical, then make a V, and, finally, make the last stroke almost vertical.

You will notice that the first and third strokes are not parallel, nor are the second and fourth.

For the W, first make a fairly narrow V, then make the third and fourth strokes parallel to the first and second.

A frequently unnoticed characteristic of Roman letters is the almost straight top on the C, the G, and the S. The common perception is that the tops are curled.

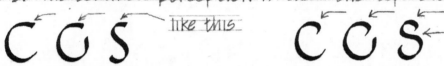 like this

 not this
not curly here either

If the proper cant of the pen is adhered to, the round letters will be formed with a marked axis to the left.

The U can be made with uniform-width verticals and a foot, or with the second vertical thinner and no foot.

U ← this or this → U

The smallest Roman letters the C4 pen can make without their being too squat are about ¼ inch high. Here is an example written out with a C4 pen.

ARCHITECTURE IS MAN'S TOTAL PHYSI-CAL SURROUNDINGS, OUTDOORS AND INDOORS.

An even better proportion is achieved by ¼-inch letters made with a C5 pen.

THE PURPOSE OF ARCHITECTURE IS TO SHELTER AND ENHANCE MAN'S LIFE ON EARTH AND TO FULFILL HIS BELIEF IN THE NOBILITY OF HIS EXISTENCE.

EERO SAARINEN
"REMARKS AT DICKINSON COLLEGE"

5/32-inch letters made with a C6 pen.

TO GRASP SPACE, TO KNOW HOW TO USE IT, IS THE KEY TO THE UNDERSTANDING OF BUILDING.

BRUNO SEVI
ARCHITECTURE AS SPACE

Even smaller sans serif letters, 3/32 inch high, made with a C6 pen.

I THINK OF ARCHITECTURE AS THE TOTAL OF MAN'S MAN-MADE PHYSICAL
SURROUNDINGS. THE ONLY THING I LEAVE OUT IS NATURE. YOU MIGHT SAY IT
IS MAN-MADE NATURE. IT IS THE TOTAL OF EVERYTHING WE HAVE AROUND US,
STARTING FROM THE LARGEST CITY PLAN, INCLUDING THE STREETS WE DRIVE ON
AND ITS TELEPHONE POLES AND SIGNS, DOWN TO THE BUILDING AND HOUSE WE
WORK AND LIVE IN AND DOES NOT END UNTIL WE CONSIDER THE CHAIR WE SIT
IN AND THE ASH TRAY WE DUMP OUR PIPE IN.

EERO SAARINEN
"REMARKS AT DICKINSON COLLEGE"

An elegant look results from making 1/4-inch letters with a C6 pen.

IMAGES WERE FIRST MADE TO CONJURE
UP THE APPEARANCE OF SOMETHING
THAT WAS ABSENT.

JOHN BERGER
WAYS OF SEEING

67

Roman letters usually have a thin cross stroke at the top and bottom of a letter, called a serif. Far from making execution more difficult, adding serifs to letters makes the alphabet easier. Serifs cover a multitude of sins.

To make Roman Square Caps it is necessary only to add small straight serifs. The serif is a thin parallelogram – a tiny section of a horizontal stroke → ▬

- First make the stem → **I** then add serifs **I**
- Many serifs are simply an extension of the horizontal stroke. **B P D F**
- For E and L flick the end of the stroke up **E L**
- Several letters have special characteristics. For R, A, M, K, and X, flatten the pen to make the stroke sit on the line. **R A M K X**
- The right-hand serif of the T pulls down and left **T** following direction of pen.
- The serifs on C, G, and S pull down and left. **C G S**
- ALL SERIFS ARE MADE WITHOUT CHANGING THE CANT OF THE PEN.

Quarter-inch Square Caps made with a C5 pen are cool and refined.

DESIGN MUST BE AN INNOVATIVE, HIGHLY CREATIVE CROSS-DISCIPLIN-ARY TOOL RESPONSIVE TO THE TRUE NEEDS OF MEN.

VICTOR PAPANEK
DESIGN FOR THE REAL WORLD

Smaller Square Caps can be less stiff. These, 3/16 inch high, are made with a C5 pen.

PERSPECTIVE MAKES THE SINGLE EYE THE CENTER OF THE VISIBLE WORLD. EVERYTHING CONVERGES ON TO THE EYE AS TO THE VANISHING POINT OF INFIN-ITY. THE VISIBLE WORLD IS ARRANGED FOR THE SPECTATOR AS THE UNIVERSE WAS ONCE THOUGHT TO BE ARRANGED FOR GOD.

JOHN BERGER
WAYS OF SEEING

69

A ground-down Crow Quill or Hawk Quill (Speedball) point is a fine tool for making very small letters. On an Arkansas oilstone or other fine-textured stone, pull the pen toward you as though you were making a vertical stroke. Repeat this until the tip is ground to the desired flat end. Turn the pen over and gently stroke it once or twice to remove the burr. Examples below are done with a ground-down Crow Quill, at 3/32 inch and 4/32 inch.

IF DESIGN IS ECOLOGICALLY RESPONSIVE, THEN IT IS ALSO REVOLUTIONARY. ALL SYSTEMS – PRIVATE CAPITALIST, STATE SOCIALIST, AND MIXED ECONOMIES – ARE BUILT ON THE ASSUMPTION THAT WE MUST BUY MORE, CONSUME MORE, WASTE MORE. . . . IF DESIGN IS TO BE ECOLOGICALLY RESPONSIBLE, IT MUST BE INDEPENDENT OF CONCERN FOR THE GROSS NATIONAL PRODUCT.

VICTOR PAPANEK
DESIGN FOR THE REAL WORLD

RUINS DESTROY SCALE TO SOME EXTENT AND SPACE EVEN MORE AND WE ARE PRONE TO CONJECTURES WHICH MAY ERR ON EITHER SIDE OF THE REALITY. THE HYPOSTYLE OF KARNAK WITHOUT ITS ROOF IS TOO LIGHT INSIDE; THE SUN SHINING THROUGH DEMOLISHED WALLS OF THE PARTHENON MAY BE GREAT FOR COLOR PHOTOGRAPHY BUT IS DECEPTIVE. . . .

JOHN ELY BURCHARD
BERNINI IS DEAD?

Italic Alphabet in Ink

Italic is a lowercase style of great sophistication. Large italic letters can be very effective for headings on presentation sheets, and also make an attractive block of descriptive material.

Italic is by definition slanted. It has narrow letters characterized by a spiky look. Although a mild slant is the accepted one, it is more important to be consistent, a trait easier to achieve at the slant that seems to come to the writer's hand most naturally. The slant is accompanied by a cant of approximately 45°.

Italic letters are five pen widths high for the body of the letter, five more pen widths for the ascender, and five pen widths for the descender.

ASCENDER ⟶
BODY OF LETTER ⟶ *fgd*
DESCENDER ⟶

Two basic strokes will make almost all the letters of the alphabet:

The push stroke, which starts the A, C, D, G, Q, and S. With the pen canted at 45°, push pen to the left, drop down, pull up, and drop down again for the stem.

A is a one-stroke letter.

Use the same push stroke to start these letters.

The second basic stroke is the entry and exit from the stem. Lead into the stem stroke with the thin edge of the pen; angle the stroke into and out of the stem.

ANGLE

ANGLE

r l m n — start the branching halfway up the stem.

M, N, R, H, B, K, and L are made with one stroke. *h r b k l*

← PUSH

G and Y are also one stroke. *g y*

P, D, F, T, W, and X are two-stroke letters. *p d f t w x*

The rest of the letters. *e* TAKE LOOP INTO STEM HALFWAY *u j v o*

DO NOT CHANGE THE CANT OF THE PEN (EXCEPT FOR THE OBLIQUE OF THE Z).

In other words, do not turn the pen in the hand; the chisel end will make the proper thicks and thins by itself.

Z TURN THE PEN SLIGHTLY FOR THE OBLIQUE SO THAT THE STROKE IS NOT TOO NARROW.

The following example of italic was written out with a C6 pen.

The enormous size of the statues and ornaments in St. Peter's does away with the impression of its vast size and it is only by observing the living, moving figures that one can form any idea of its colossal proportions. A line in the pavement is marked with the comparative size of the other great Christian churches. The height of the dome in the interior is 405 feet.

AUGUSTUS HARE
WALKS IN ROME

Italic with a C6 pen at a body height of 1/16 inch.

The baldacchino, designed by Bernini in 1633, is of bronze with gilt ornaments, and was made chiefly with bronze taken from the roof of the Pantheon. The first impulse will be to go up to the shrine, at which a circle of eighty-six gold lamps is always burning around the tomb of the poor fisherman from Galilee, and to look down into the Confession, where there is a beautiful kneeling statue of Pope Pius VI.

AUGUSTUS HARE
WALKS IN ROME

Italic lowercase letters may be accompanied by either Roman Square Caps or by a decorative letter, usually called a Swash Cap. Capitals may be either straight up and down or slanted.

A great deal of individuality is permissible in Swash Caps. Here is a selection of moderately swashed capitals, straight and slanted.

ABCDEFGHIJKLMNOPQRST
UVWXYZ

ABCDEFGHIJKLMNOPQRSTUVWXYZ

Johnnie Crack and Flossie Snail
Kept their Baby in a Milking Pail
One would put it Back and One would Pull it Out
And all it had to Drink was Ale and Stout
For Johnnie Crack and Flossie Snail
Always used to say that Stout and Ale
Was GOOD for a Baby in a Milking Pail

DYLAN THOMAS
UNDER MILKWOOD

Humanist Bookhand Alphabet in Ink

If the Romans had had a formal lowercase it would surely have looked like Humanist Bookhand. The same dignity, structural integrity, and clarity are evident in the minuscules as in the majuscules. There is one noticeable difference—the Humanist letters are not proportionate in their widths. It is a uniformly wide face.

- The body of the letter height is five pen widths. The ascenders are three pen widths and the descenders are three pen widths.

- Stem strokes are started with a "club" serif.

Pull to the left on the thin edge of pen, then down right on wide edge.

Second stroke covers right side of serif.

The following letters all begin with club serifs:

b c d h i j k l m n j p r u y

KEEP BACK-
BONE STRAIGHT

KEEP TOP
STRAIGHT

BRING CROSS-
BAR IN HALF-
WAY

DON'T HOOK
TOP TOO
MUCH

G IS A COMPLEX
LETTER: MAKE TOP
CIRCLE MORE THAN
HALF THE SPACE

KEEP EAR
STRAIGHT
BOTTOM LOBE
IS FLATTENED

ALL ROUND
LETTERS ARE
FAT

FLATTENED CURVE
ON TOP AND
BOTTOM OF S

T JUST BREAKS
THROUGH TOP
GUIDELINE

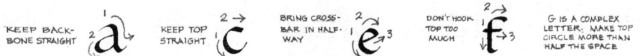

Does Bookhand look familiar? It is the style used on most typewriters.

Use Roman Square Caps with Humanist Bookhand.

Balthasar Neumann's debt to Gothic archi-
tecture is considerable and this is even more
plainly visible in the exterior of Vierzehnheiligen.
The Gothic quality of the interior has also been em-
phasised by the Rococo stucco work lavished on the
vaults while the walls are left almost entirely bare.

P. AND C. CANNON-BROOKES
BAROQUE CHURCHES

For special effect, the ascenders in the top row of lettering can be exaggerated;
similarly, the descenders of the bottom line.

wherever the institution of private property
is found the economic process bears
the character of a struggle between
men for the possession
of goods

THORSTEIN VEBLEN
THE THEORY OF THE LEISURE CLASS

76

Alphabet Variation in Ink

A less formal and easier way to use the wide-edged pen is in imitation of lowercase pencil letters. Cant the pen to an extreme angle so that the stem (downstroke) is narrow and the horizontal is wide. Keep the pen upright.

today's young are never told that they were born into a shrinking world in the sense that the sum total of things that have become extinct is greater than that of those that exist today

BERNARD RUDOFSKY
THE PRODIGIOUS BUILDERS

This style has a racy character when used with all caps.

BE AWARE OF LETTER SHAPES. A SOLID GRASP OF QUALITY AND RHYTHMIC SPACING IN LETTERFORMS IS A GREAT HELP TO YOUR OVERALL UNDERSTANDING OF THE PRINCIPLES OF ART.

FRIEDRICH NEUGEBAUER
THE MYSTIC ART OF WRITTEN FORMS

Numerals in Ink

Numbers need to match the style of the letters. When formed with a chisel-ended pen the symbols look like those below. These are Arabic numerals.

Keep the pen cant consistent throughout.

1 2 3 4 5 6 7 8 9 0

If serifed letters are being used, the numbers also should have serifs, where suitable.

1 2 3 4 5 6 7 8 9 0

The numbers above, being quite wide, are compatible with Bookhand. Thinner numbers should be used with italic and may slant or not, as you choose.

1 2 3 4 5 6 7 8 9 0 1 2 3 4 5 6 7 8 9 0

Numbers that go above and below the line are called Old Style. Ones that keep within the writing lines are called New Style.

1 2 3 4 5 6 7 8 9 0 1983

Once in awhile it is necessary to use Roman numerals. They need to be meticulously made so as not to look sloppy.

I =ONE V =5 X =10 L =50 C =100 D =500 M =1000

• Strokes are added up to 3 (I, II, III) and thereafter a single symbol signals subtraction from the following symbol. IV =4 IX =9 XL =40 CD =400

XIV =14 XIX =19 XVIII =18

I II III IV V IX X XIV XX XL D C M

• Roman numerals may also be written in lowercase, although this is usually done only on the typewriter. xxviii

APRIL MCMLXXXIII

79

Pen Types

- The RAPIDOGRAPH is a fountain pen that has a cylindrical nib with the ink flowing out of a small-diameter tube. It produces a line of the same width in any direction. Nibs range from the very small, 6x0, to the largest size 14. The small nibs tend to clog easily. Great care must be taken to keep them clean. The pen uses ink cartridges.

- OSMIROID fountain pens have chisel ends that produce a thick and thin stroke. They come in six sizes, from fine to broad. The pen has a lever or screw plunger filler. Left-handed nibs are available.

- PELIKAN GRAPHOS makes both cylindrical nibs and chisel ends for a fountain pen barrel.

- The PLATIGNUM lettering set comes with a fountain barrel and six inter-changeable chisel-ended nibs.

- MARSMATIC pens are similar in style to Rapidographs.

Fountain pens with chisel ends are practical because they are not dependent on an ink bottle. They are ideal to have on hand for the odd moment's practice or for lettering a quick card stylishly. The letters themselves reflect the inflexible nature of the nib. Points of the Speedball variety produce letters with more character.

LARGE-SCALE LETTERS

The following section contains an abbreviated look at large letters suitable for headings, titles, display, and presentation.

Large letters are usually drawn out and filled in, or in other ways built up by multiple strokes. The letters shown on the following pages have all been mechanically made, i.e., using tools such as the T square, triangle, and compass, to achieve accuracy. The student should not be afraid of enhancing these letters by filling them in, outlining, texturing, and above all by using color.

Press-on letters are one answer to large letters but they have shortcomings. They are expensive and not always available in the desired size or face. They are prone to flaking off and scratching, and they do not survive the blueprint machine. They are not of archival quality.

Structurally, the simplest letters are big, bold block letters. They are made mechanically using the following method:

Base each letter on a square five units high. Using a T square or parallel bar, rule six equidistant lines. Then make squares using the 45° triangle. The diagonal of the triangle from the top line to the bottom line will measure a square. Leave a small space between each square.

Draw out the lettering on a piece of tracing paper first. Words can be cut out and respaced, and stuck together with tape until the desired effect is achieved. When ready, black the back with a medium-soft pencil, tape lightly in place, and trace over the letters with a sharp pencil. This will transfer the image to the good sheet. Using a straightedge outline the letters with a ruling pen and compass and fill in with a brush or pen. Ruling pens are not dipped but filled from the side with the squeeze top of the ink bottle.

Ragged ends can be removed from vellum or illustration board using an electric eraser, or by scraping with a sharp knife and then using a soft eraser.

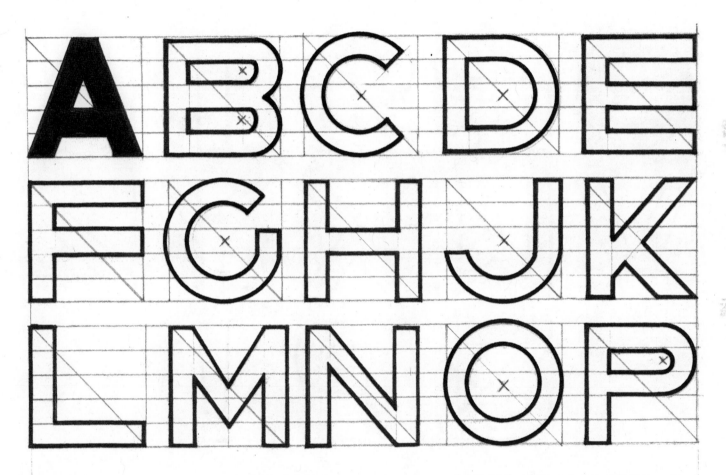

The diagonal line crosses each horizontal at a square unit. The pencil X marks the compass point.

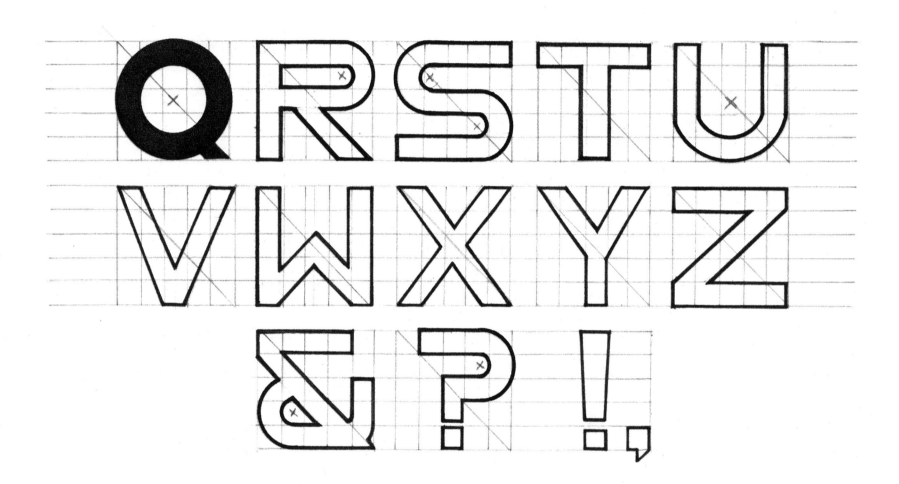

Changing the proportions of letters changes their looks enormously. Simply add units to the letter height. Since this does mean that circles (easily made with a compass) have become ovals (not so easily made), keep a rectangular form and round the corners.

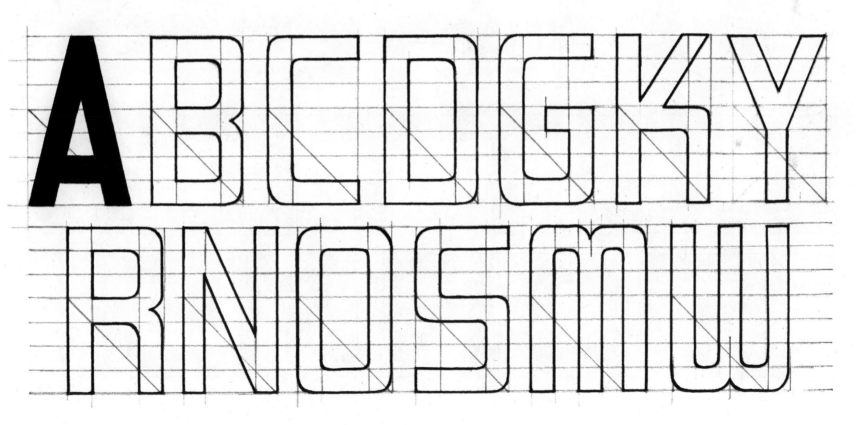

Outlined letters are effective and not as heavy looking as solid ones. Use straightedge and compass.

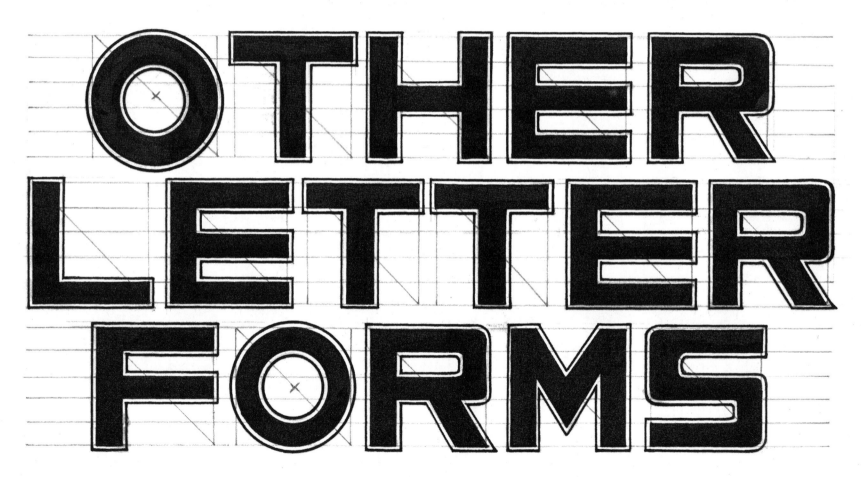

Below is a lowercase alphabet in which the body of each letter is based on a square of four units. No need to use capitals with these.

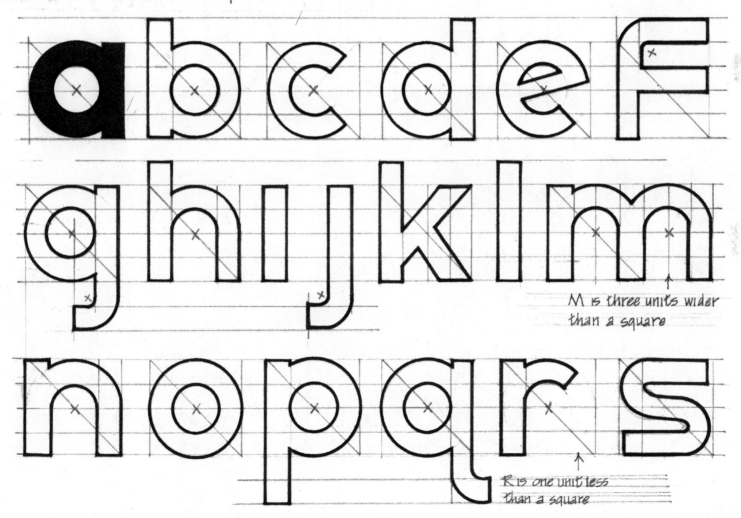

M is three units wider than a square

R is one unit less than a square

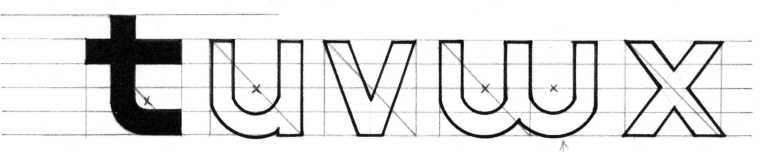

W is three units wider
than a square.

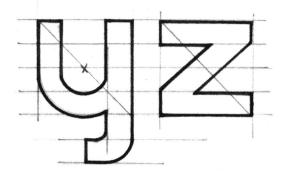

The ends of S may be
shortened a little.

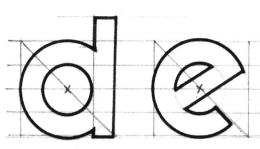

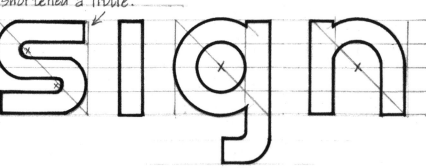

Another constructed letter using very thin lines made with ruling pen and compass.

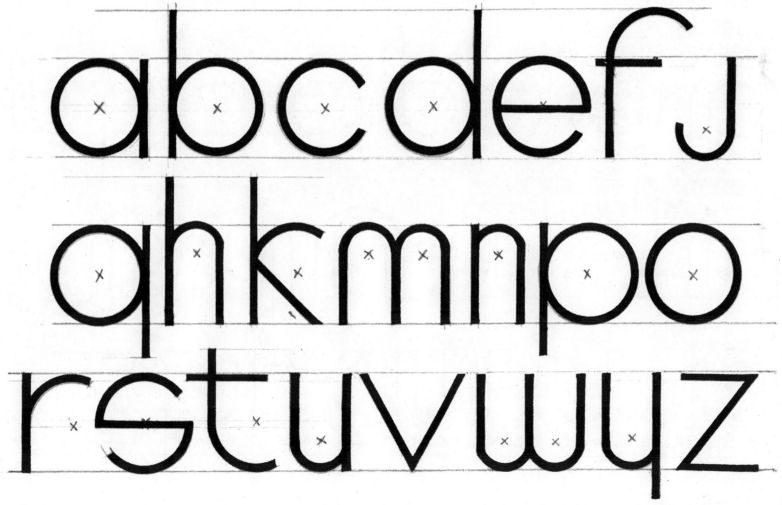

Streamline the letters for a modern look. This is based on a face called Bauhaus Bold. It can be constructed easily with straightedge and compass.

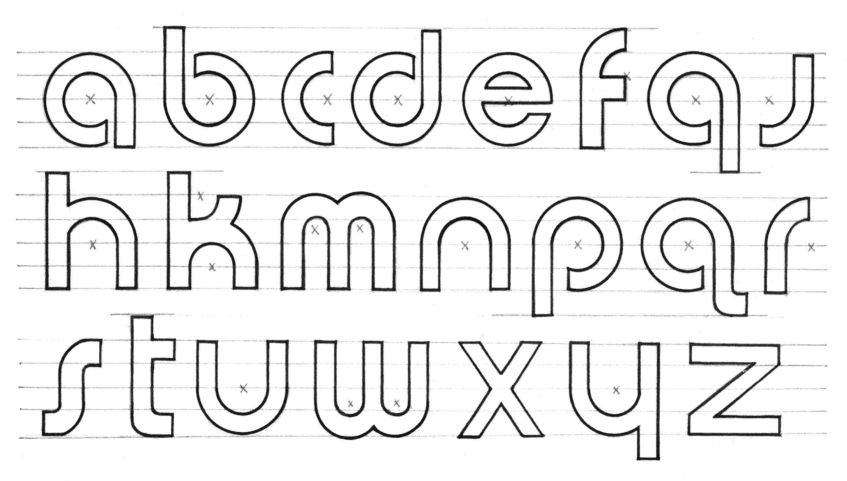

Leaving a stripe in the middle of the letter adds interest. Unevenness in white lines, if neat and mechanical, is not objectionable.

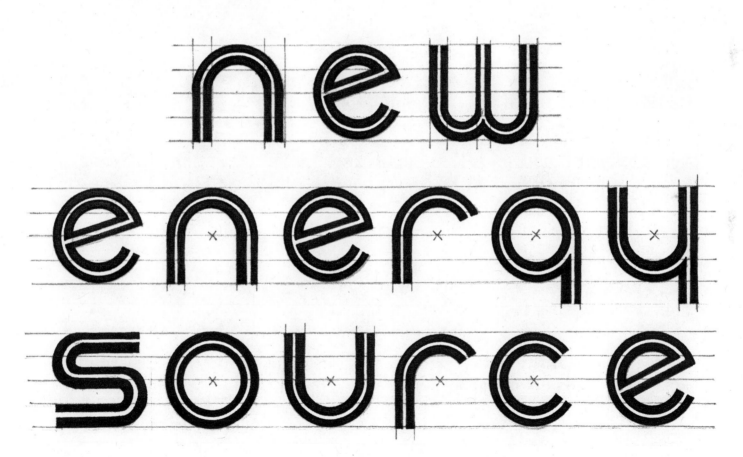

Using a stencil is another mechanical means of producing larger letters. The smaller the stencil the less clear and sharp the letters. Letters may be left as outlines or filled in.

Light cardboard stencils (above) are inexpensive but oblige the user to accommodate to the spacing guides used on the stencil. The pencil dots indicate the spacing guides.

Clear plastic stencils (below) allow flexibility in spacing. There are many of these on the market.

It is possible to adapt almost any style of lettering to a stencil character. Stencil style is appropriate to an informal presentation.

ABCDEGKMNPRS

Adaptation of stencils can be very creative. The following alphabet was a "Special Problems in Design" assignment done by a graduate student, Jane Crawford. The object was to create a new alphabet from an easily available template, and to provide instructions to make execution easy.

BATH TUB MODERNE

THIS STYLE CAN BE DONE ALMOST ENTIRELY WITH A TEMPLATE, AND WITH SOME PRACTICE IS EASY TO KEEP UNIFORM. THE LETTERS ARE EXECUTED USING A BATH TUB SYMBOL AND THE RESULTS ARE RATHER CONTEMPORARY IN DESIGN.

SPECIAL MATERIALS: HOUSE PLAN AND PLUMBING TEMPLATE. SCALE: 1/4"-1'0"

MEDIA: FINE-LINE TO HEAVY-LINE FELT-TIP PEN, CHISEL-POINT PEN, PENCIL. (DESIGN MARKERS RUN & SMEAR RATHER BADLY.)

TO BEGIN: SET LETTERING GUIDE TO FIT BATH TUB SYMBOL. ORIENT TEMPLATE SO THAT FLAT END OF TUB RESTS ON BOTTOM GUIDELINE.

ABCDEFGHJKLMNPQRST

This page has been somewhat reduced.

LETTERS:

A B C D DON'T FORGET THE SERIFS ON TOP AND BOTTOM... TO DISTINGUISH "D" FROM "O" E F G H I USE ROUND EDGE OF TEMPLATE FOR "I", COMING DOWN TO LINE.

J K ON LETTERS "K," "P," "R," "S," & "Y," IT IS NECESSARY TO MOVE TEMPLATE UP IN STRAIGHT LINE TO KEEP ROUNDED EDGES. L M ON LETTERS "M," & "W" MOVE TEMPLATE TO RIGHT TO COMPLETE LETTER N ON LETTERS "N" & "R" TURN TEMPLATE TO DIAGONAL TO COMPLETE THE CROSSBAR - MOVE TIL IT FILLS SPACE NICELY O P MOVE TEMPLATE UP

Q R MOVE TEMPLATE UP TURN TO DIAGONAL S MOVE TEMPLATE UP TURN UPSIDE DOWN T USE STRAIGHT EDGE U DON'T FORGET V W MOVE TEMPLATE TO RIGHT. LINE UP WITH BOTTOM GUIDELINE.

X Y MOVE TEMPLATE UP Z 1 2 3 4 5 6 7 8 9 MOVE TEMPLATE DOWN

94

TITLE BLOCKS

The title block is a staple of architectural drawings. It will appear in the same place on every page of working drawings. Sometimes the block is a strip extending completely across the page; more frequently, it is a box in the lower right corner. The block is divided into sections to accommodate various types of information. The largest space will be for the name of the project, the client's name and address, and the name of the architect or firm. The page number should be in the right-hand corner where it catches the eye. It is usually accompanied by the total number of sheets, in order to make a set easy to check. Sometimes the scale of the drawings is included, and there should be a place for the date. In a large office, there may be spaces for initialing or signing to approve various stages of work.

Vellum sheets are available with the title block divisions already printed on the page; however, these may or may not be suited to the job one is doing.

Working drawings are destined to be reproduced in some manner, first because multiple copies are necessary for distribution to contractors, carpenters, etc, and second, in order to preserve the originals. In order to print well, the drawings and title blocks must be crisp, clear, and dark. Pencil is widely used because errors are easy to correct. An HB or #2 pencil is good. It must be kept sharp. If ink is used, it will probably be necessary to do a complete preliminary sheet and then go over it in ink. Of course, ink produces a very clear print. Rapidograph pens with interchangeable nibs are excellent for this purpose.

Here are some examples of title blocks. Use heavy lines for the blocks.

This one would extend across the bottom of the sheet. It has been greatly reduced.

| JOB NO. | DATE | FAR INN SCOTT, ARKANSAS | SMITH & ASSOCIATES ARCHITECTS | 5/12 |

This kind is for the lower right corner of the sheet.

| RESIDENCE FOR **J. A. SHERMAN** 27 B SIZEMORE DRIVE OTIS, MINNESOTA | SHEET **3** OF **TEN** |
| HORN BLOW ASSOCIATES OTIS, MINNESOTA | |

The printed form, reduced in size, looks like this.

SCALE: DATE:	APPROVED BY	DRAWN BY
		DRAWING NUMBER

Title blocks can incorporate the firm logo or the company name in a distinctive lettering style.

The Architects Collaborative of Boston uses this title block.

JOB NO	
DRAWN	
CHECK	
SCALE	
DATE	SHEET NO.

The illustrations on pages 32 and 33 are from title blocks.

PRESENTATION SHEETS

The execution of a presentation sheet is as important as the competent design of the project itself. Usually a perspective drawing and the name of the project are the major components of such a sheet, and are of equal importance. A skillful integration of the two depends on scale, value, color, and style. Naturally the style of the text should be in keeping with the spirit of the project. This correspondence can take many forms.

Dignified, lighthearted, modern, camp, mechanical, brisk, smooth—these are some of the adjectives that can describe both letters and architecture. Be careful with special effects such as making letters out of bamboo, pretzels, or Lincoln Logs in an effort to develop a connection between the title and the drawing. There is the very real possibility of being corny or cute.

Following are some alphabets that have useful qualities. These are not freehand alphabets. They must be drawn out carefully and then inked in.

This script is smooth, flowing, and high class. It is just as pleasing in lowercase as in upper.

abcdefghijklmnopqrs
tuvwxyz

ABCDEFGH

I J K L M N O

P Q R S T U

V W X Y Z

Ascenders and descenders can be exaqqerated for effect.

Geometric, layered, perhaps rustic...

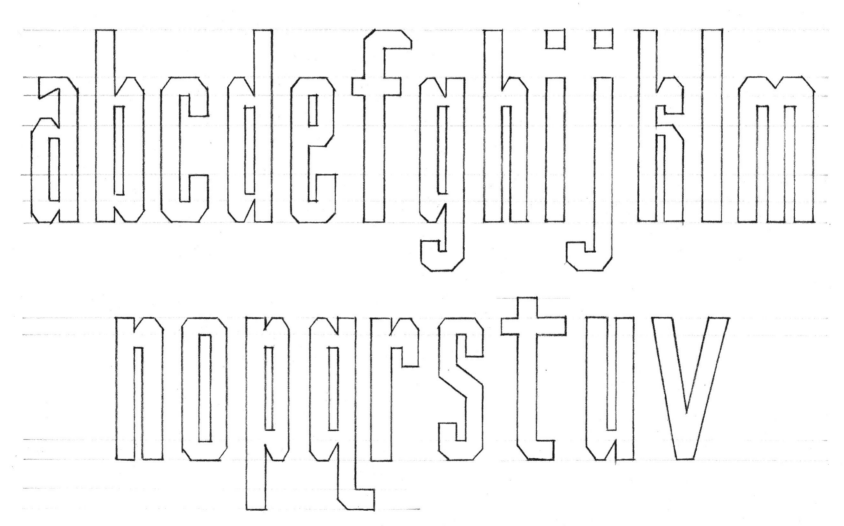

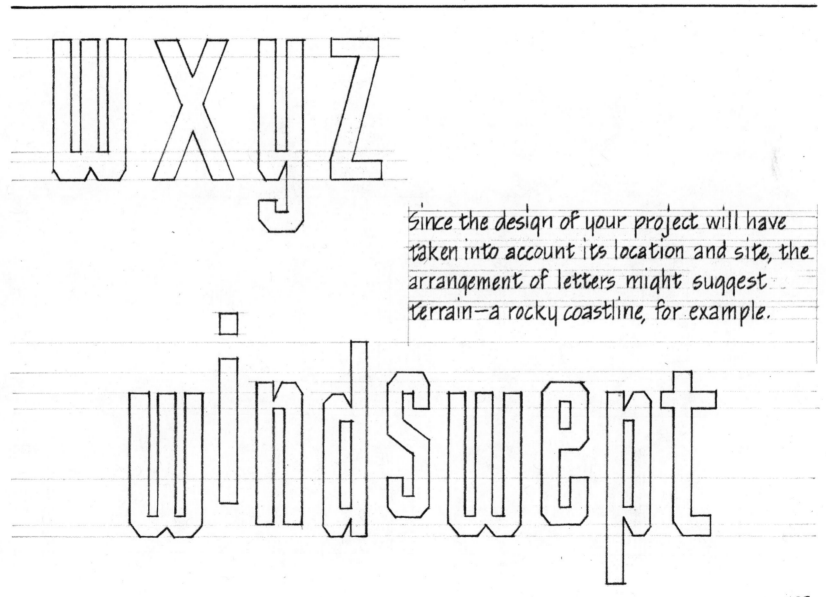

WXYZ

Since the design of your project will have taken into account its location and site, the arrangement of letters might suggest terrain—a rocky coastline, for example.

windswept

Roman letters connote dignity, security, and wealth.

A B C D E F G

H I J K L M N

O P Q U R S T

VWXYZ

1234567890

STILL WATER

YACHTS

This alphabet is modern, young, and people oriented.

abcdefg
hijklmn
opqrst

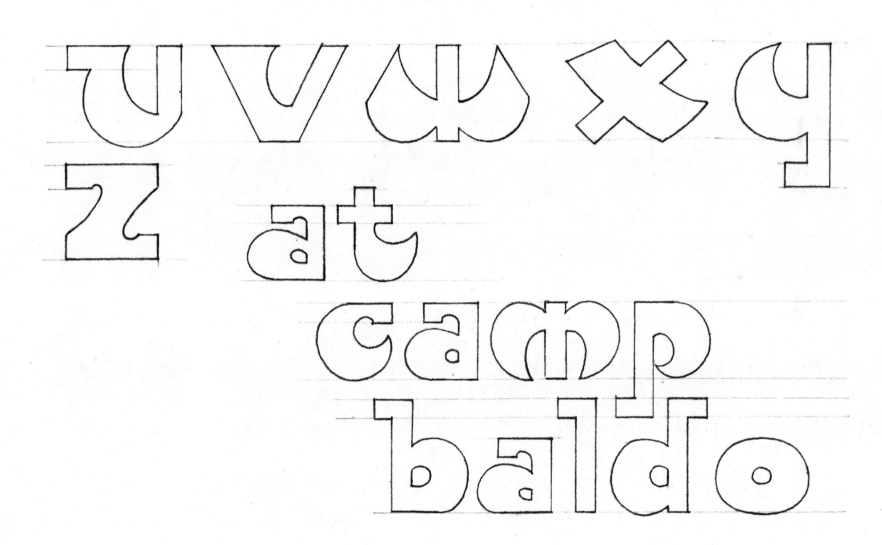

u v v w x y
z at camp
baldo

A three dimensional effect is sometimes fitting and always eye-catching.

Jobs in historic preservation, restoration, and adaptive reuse provide opportunities to use period alphabets such as Black Letter (Gothic), Celtic, Art Deco, or Art Nouveau.

All Black Letter styles have not only Gothic, but ecclesiastical connotations.

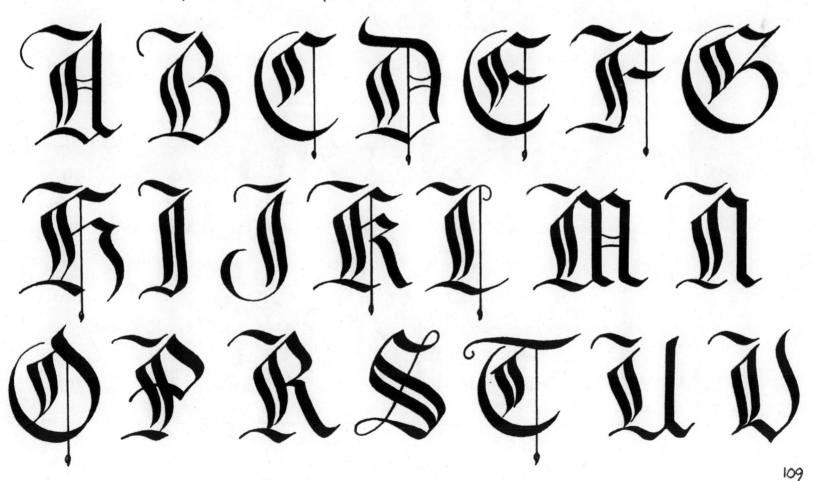

W X Y Z Q

a b c d e f g h i j k l m n o

p q r s t u v w x y z

There are two rules in using Black Letter.
1. Never write out a whole word in Black Letter capitals. It will be illegible. Use capitals with the lowercase letters.
2. Space lowercase letters close together.

New Trinity
Methodist

Charing Cross Market ❖ ❖ ❖ ⁓⁓

These capitals, adapted from those designed by the great artist Albrecht Dürer, are famous and very beautiful. Use the lower case letters from the preceding page with them.

A B C D E F G

H I J K L M N O P

R S T U V W X

Y I Q

Benoit, S.J.

Marymount

Some assorted Celtic capitals.

ABDEFH

MNPSTU

AbbeyTheatre

Handsome large letters can be made using swelled heads and feet. The curved stems are easily stroked Free-hand and need not be mechanically perfect. Use guide lines top and bottom.

ABCDEFGHIJKL
MNOPQRSTUV
WXYZ

University Heights
CONDOMINIUMS

Steel Brushes

Steel brushes are actually large pens. They come in assorted sizes—¼ inch, ⅜ inch, ½ inch, and ¾ inch. They make giant letters.

Letters produced by steel brushes have very contrasty thicks and thins. Script letters are good with this kind of contrast. Writing out the letters freehand, then tracing them to clean up the edges, will result in a more lively, less mechanical-looking letter than those that are drawn out.

Garden

The unretouched example above was made with a ½ inch steel brush. It has been reduced 75 percent.

Steel brushes are good for laying out straightaway easy letters like these. Trace, to crisp up the edges.

ABCD

EGKM

NORS

Letter Enhancement

Letters can be enhanced in order to give them more importance, to fill up space, to relate them to their surroundings, or to use additional colors.

Outlines are easy and quick...thick or thin, single or double, even triple.

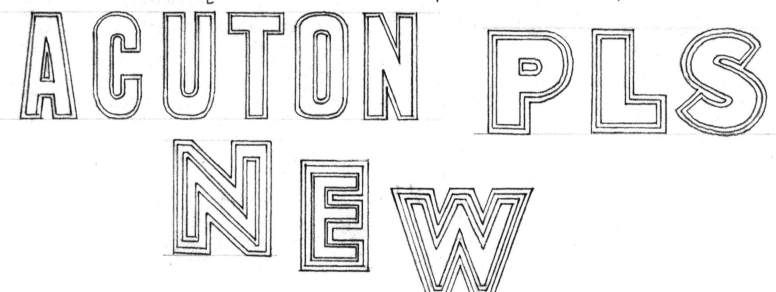

Outlines can be neatly executed with parallel bar and triangle, or they can be more casual. Freehand lines can overlap at the corners or be stressed with tiny dots.

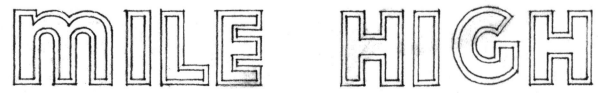

Letters can be outlined as a group.

DESIGN STUDIO

Try a change of value, or textured infill.

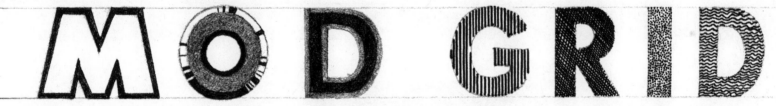

MOD GRID

Zip-a-Tone or Formatt is good for large, simple letters. Cut the letters with a sharp X-Acto knife. Zip-a-Tone and Formatt will go through the blueprint machine.

CADD

Zip-a-Tone or Formatt make interesting textured blocks.

Do not overlook the wonders of a quick blast from a can of spray paint, with or without using a stencil.

Give your letters added pep by putting them on top of a color block. Stroke in a background with a wide-edged colored marker, freehand or using a T sqare. Uneven edges and the striped effect of overlapping strokes relate well to an informal letter.

Some markers use fluid that flows together, leaving a relatively smooth surface. The other kind dries in noticeable stripes.

Save old markers. They will produce a dry-brush technique.

Presentation sheets are generally reproduced photographically when necessary, so that halftone effects, even if not in color, will be successful. The blueprint machine will produce halftones whose quality depends on exposure time.

Shadows and other three-dimensional effects are valuable graphic devices. To make shadows it is necessary to assume a light source. More often than not it is at the upper left. Thus, shadows are cast from the bottom and right of the letters. Leaving a slight space between shadow and letter adds a little liveliness.

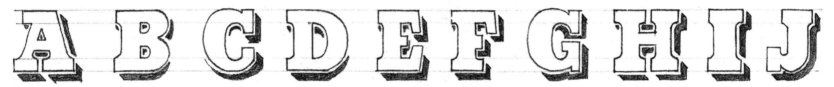

Adding thickness to letters is similar to shadows but gives a different look. Use an adjustable triangle to ensure consistency in the oblique strokes.

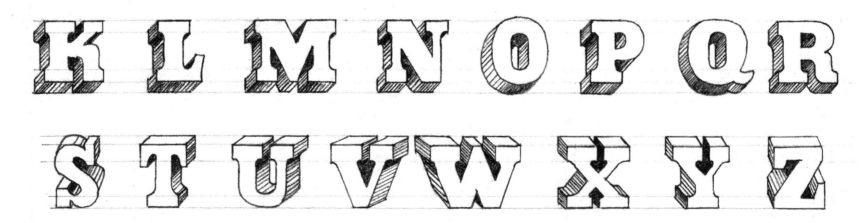

Numerals

Numerals can be an important part of the page layout. Use them for dramatic effect, as color spots, or as a device for continuity. They can be plain or fancy.

PLAIN BLOCK

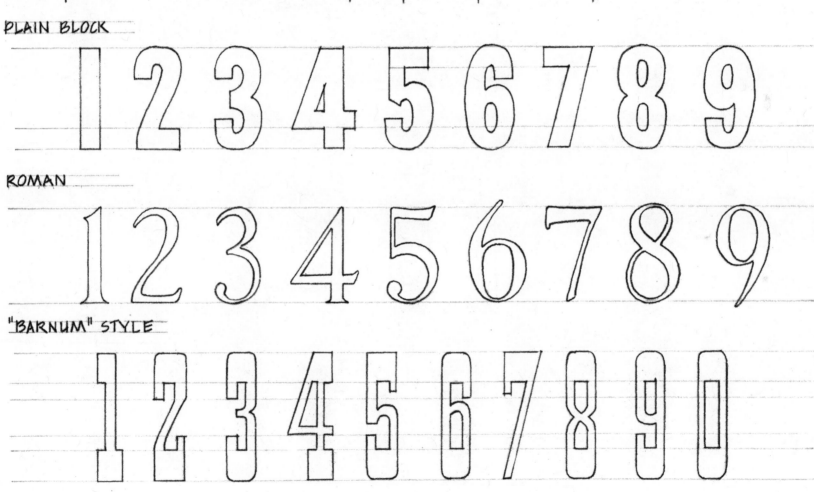

ROMAN

"BARNUM" STYLE

Baroque numerals are particularly effective used separately.

1 2 3 4 5 6 7 8 9 0

Variations on Baroque numerals

2 2 3 4 5 6 7 8 9

1 2 3 4 5 6 7 8 9

Reversed Values

Reversing values is a good technique for symbols such as arrows and numerals. Light figures on a dark background are always dramatic but are difficult to achieve without a stencil. Because of the difficulty of getting a solid white or a smooth light tone on top of a dark background it is always better to use a stencil or to color the background in around the letter.

RULE: If you are going to draw out letters and darken around them, make the letters fatter than you think necessary—they will seem to shrink in size.

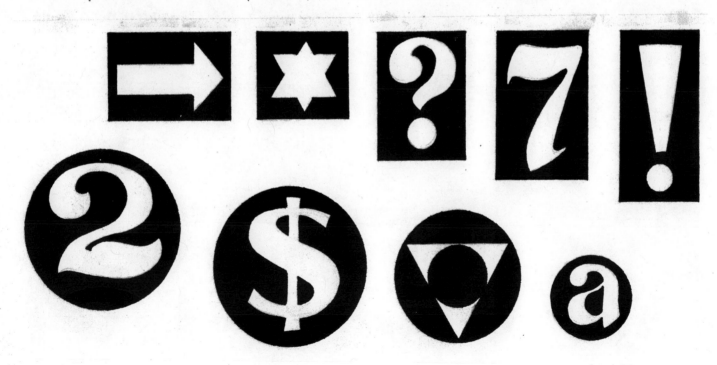

Felt-Tipped Markers

Felt-tipped markers are a staple in most offices, for use in rendering. The transparent tint that the wide chisel-ended tool lays down has a unique effect. It is generally used as a broad non-specific base for details laid on top. Many times the same marker technique used in laying in the background of an illustration or a perspective can be successfully used in the lettering, particularly if the same colors are chosen.

Designer Edward White suggests that if you cannot cope with SLICK it is better to go with SKETCHY. Markers are quick, effective, nonslick tools for big letters. They need to be executed with confident SINGLE strokes. Going over lines shows up as a change in value.

Caution: Marker color may spread with age or may in other ways not be as permanent as you might wish. It is definitely not archival and may not even be stable enough for portfolios. However, for reproduction purposes it will print on the ozalid machine, or of course, photographically.

ABCDEFG

HIJKLMN
OPQRST
UVWXYZ

ABCDEFGHI
JKLMNOPQR
STUVWXYZ

Freehand outline with Pilot Fineliner or Razor Point. A certain uneven quality in freehand lettering adds personality.

RELEVANCE
CONSUMER
STANDARD

UNDERSTAND
CLARITY
OVERHEAD

Various kinds of infill.
Infill technique is useful in toning down colors that are too bright.

MISSISSIPPI NATIVE PLANT CENTER

THE CROSBY ARBORETUM

TOP OF BRICK WALL

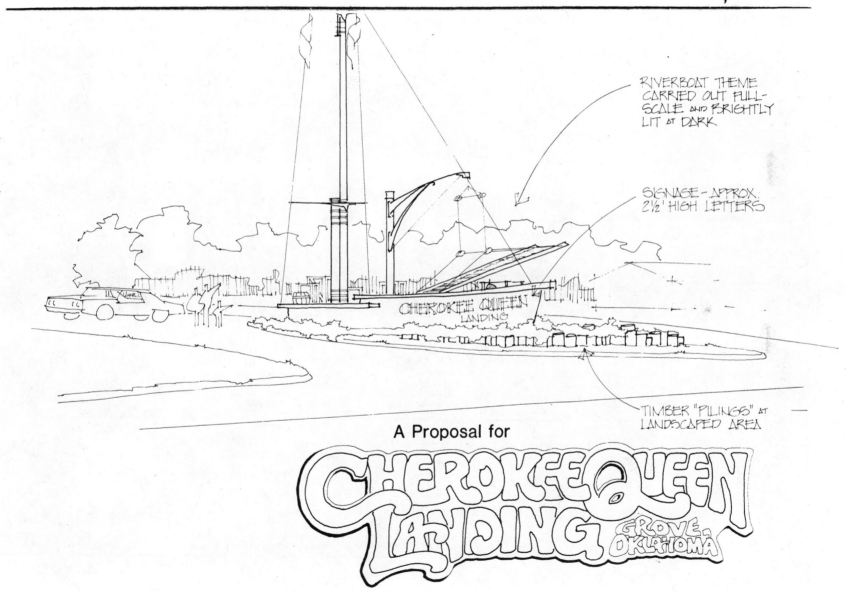

RIVERBOAT THEME CARRIED OUT FULL-SCALE and BRIGHTLY LIT at DARK

SIGNAGE - APPROX. 2½' HIGH LETTERS

CHEROKEE QUEEN LANDING

TIMBER "PILINGS" at LANDSCAPED AREA

A Proposal for

CHEROKEE QUEEN LANDING GROVE, OKLAHOMA

INDEX

INDEX

INDEX

ABOUT THE AUTHOR

Martha Sutherland is an Assistant Professor of Architecture at the University of Arkansas, where she has taught lettering and graphic fundamentals since 1978. In 1984 she was nominated for Outstanding Woman Faculty Member in the university's School of Architecture. She is the author of two other books on lettering, including the popular first edition of Lettering for Architects and Designers. Ms. Sutherland also maintains an active freelance illustration business and has presented numerous papers at national and international conferences. She earned her B.F.A. from Carnegie Mellon University and her M.A. from the University of Arkansas.